Digital Art History
A Subject in Transition

Computers and the History of Art Volume One

Edited by

Anna Bentkowska-Kafel, Trish Cashen and Hazel Gardiner

intellect™

First Published in the UK in 2005 by
Intellect Books, PO Box 862, Bristol BS99 1DE, UK
First Published in the USA in 2005 by
Intellect Books, ISBS, 920 NE 58th Ave. Suite 300, Portland, Oregon 97213-3786, USA

A catalogue record for this book is available from the British Library.

ISBN 1-84150-116-6
ISSN 1743-3959
Cover Design: Gabriel Solomons
Copy Editor: Julie Strudwick

Printed and bound in Great Britain by Antony Rowe Ltd.

Digital Art History
A Subject in Transition
Exploring Practice in a Network Society

Computers and the History of Art, Yearbook 2004, Volume 1

Edited by Anna Bentkowska-Kafel, Trish Cashen and Hazel Gardiner

This edition is drawn from papers presented at the CHArt annual conferences held at the British Academy, 27-28 November 2001 and 14-15 November 2002 respectively. The CHArt Committee refereed the conferences and papers. With the exception of William Vaughan's article, the papers are also available online at www.chart.ac.uk. William Vaughan's article is an expanded and revised version of a text published in the proceedings of the EVA Conference *Electronic Imaging and the Visual Arts*, 25 July 2002, Imperial College, London, pp. 1.1-5. It is also available online in *zeitenblicke* 2 (2003), Nr. 1 [8 May 2003], www.zeitenblicke.historicum. net/2003/01/vaughan/index.html.

Dunja Kukovec, Ljubljana, Slovenia
Phillip Purdy, Museums, Libraries and Archives Council, London, UK
John Sunderland, London, UK
Tanya Szrajber, British Museum, London, UK
William Vaughan, Birkbeck College, London, UK
Suzette Worden, Curtin University of Technology, Perth, Australia

CHArt, School of History of Art, Film and Visual Media, Birkbeck College, University of London, 43 Gordon Square, London WC1H 0PD. Tel: +44 (0)20 7631 6181, Fax: +44 (0)20 7631 6107, www.chart.ac.uk, Email: publications@ chart.ac.uk.

Table of Contents

Contributors

Anna Bentkowska-Kafel is currently working on digitisation of images for the Corpus of Romanesque Sculpture in Britain and Ireland (www.crsbi.ac.uk) and is Researcher for the Digital Image Archive Group at Birkbeck College, London. Her research, teaching and publications have been mainly on early modern visual culture in Western Europe, with special interest in cosmological and anthropomorphic representations of nature; as well as the use of digital imaging in iconographical analysis and interpretation of paintings. She has an M.A. in the History of Art (Warsaw), M.A. in Computing Applications for the History of Art (London) and Ph.D. in Digital Media Studies (Southampton). She has been a member of the CHArt committee since 1999.

Trish Cashen has been involved with integrating computing into university level humanities teaching since 1993. Initially Research Officer for Art History with the CTI (Computers in Teaching Initiative), she moved to Birkbeck College where she taught on the M.A. in Computer Applications for the History of Art, and The Open University, where she is currently charged with exploiting new media for teaching arts subjects. Her main areas of interest are exploring the pedagogical effectiveness of new media and using the Internet for art history – she maintains the WWW Virtual Library for the History of Art (www.chart.ac.uk/vlib/). At present she is working on the educational potential of DVD video, as well as contributing to an interactive CD-ROM of the Soane Museum and to electronic resources for the Open University's M.A. in Art History. She has been a member of the CHArt committee since 1994.

Stephen Clancy has a Ph.D. in Art History from Cornell University. Since 1988 he has been a professor in the Department of Art History at Ithaca College in New York, where he currently serves as Chair. He teaches medieval art and architecture and Northern Renaissance painting and sculpture, as well as courses on visual persuasion and the rhetoric of art. He has also published on the fifteenth-century French manuscript illuminator and panel painter Jean Fouquet. He spent a year in Belgium on a Fulbright research scholarship studying the manuscript illumination of Simon Marmion.

Antonio Criminisi has a Ph.D. in Computer Vision from the University of Oxford. His thesis 'Accurate Visual Metrology from Single and Multiple Uncalibrated Images' won the British Computer Society Dissertation Award for the year 2000 and was published by Springer-Verlag London Ltd. in 2001. His research interests are in the area of image-based modelling, texture analysis, video analysis and editing, 3D reconstruction from single and multiple images with application to Virtual Reality, Forensic Science, Image-Based Rendering and Art History.

Hazel Gardiner is Research Officer for the M.A. Digital Art History (formerly M.A. Computer Applications for the History of Art) at Birkbeck College, and

Visiting Research Fellow at the Centre for Computing in the Humanities at Kings College, London. Until mid-2003 she was the Research Assistant for the Corpus of Romanesque Sculpture in Britain and Ireland, (www.crsbi.ac.uk), and continues to work as a voluntary fieldworker for the project. She is currently studying for a Ph.D. in twelfth-century British sculpture. She has been a member of the CHArt committee since 1997.

Margaret Graham is Director of Research, Business Information Systems, in the School of Informatics, Northumbria University, UK. Previously, Margaret was Research and Development Manager at the Institute for Image Data Research, which is now part of the School. Her research interests include image users, image seeking behaviour, and image data management. She has published in library, computing and art history areas and has presented papers on her research in IIDR at a number of international conferences.

Michael Hammel is an independent art historian working freelance as a designer and researcher in interactive media. He read Art History, Mathematics and Media at the University of Aarhus, Denmark, and Media Science at the University of Copenhagen, Denmark. He is currently working on his Ph.D. on interactive art. He has been a member of the CHArt committee since 2001.

Dew Harrison is a research fellow at Gray's School of Art for the Robert Gordon University in Aberdeen, where her research concerns digital and computer-mediated art work. Her own practice concerns non-linear narrative and the semantic association of thought and idea in multimedia form. She also works as a Director of PVA.Org's LabCulture Ltd. Prior to this she has lectured in interactive art, multimedia and new media theory and was the research fellow for the Arts and Humanities Research Board funded project Digital Art Curation & Practice: Aesthetics, Participation & Diversity, based at the University of the West of England. In this capacity she curated the international online exhibition 'Net_Working' with the Watershed Media Centre, Bristol and created and produced the DARN website (Digital Art Resource Network) set up to facilitate the practice, production and showcasing of art work in new media.

Martin Kemp is Professor of History of Art at the University of Oxford, UK. His primary research interest is in the relationship between scientific models of nature and the theory and practice of art and has published a number of books in this area. He has also pioneered computer techniques for the study of perspective and the works of Leonardo da Vinci. Most recently he co-founded Artakt (Artakt.co.uk) a vehicle for art-science research and exhibition work.

Mary Pearce completed her Ph.D. at Kingston University, UK. She has been working as a multimedia freelancer, mainly in Brazil, on the project 'Education through Art'. She is also extending her Ph.D. research on colour into distance learning modules, through the University of São Paulo. Her experience with both art and technology is extensive as she has been involved in commercial and artistic multimedia projects for some years. This, combined with continued research in art

theory and history, has enabled her to experiment with the capacity of new media technology to facilitate the teaching, understanding and analysis of artistic expression.

Jonathan Riley has previously worked in the field of Mechanical and Electronic production. He obtained a Higher TEC Certificate in Electrical and Electronic Engineering from York College of Arts and Technology in 1983, and a B.Eng. degree in Electronic Engineering from the University of Newcastle upon Tyne in 1986. Currently he is employed as Research Associate and Software Engineer for the Institute for Image Data Research (IIDR) at the University of Northumbria at Newcastle. He was involved in the development of the trademark retrieval software, ARTISAN, in association with the UK Patent Office and on Content Based Image Retrieval (CBIR) evaluation projects in collaboration with the London Guildhall Library and Bristol Biomedical Image Archive. He is presently involved in the development of a shape retrieval system for watermark images in collaboration with the Conservation Unit at the University of Northumbria.

Nic Sheen is a software analyst and project manager. After completing a degree in Astrophysics at Newcastle University, he moved to the Archaeological Sciences Department at Bradford University. His Ph.D. thesis, 'Automatic Interpretation of Archaeological Gradiometer Data Using a Hybrid Neural Network', in collaboration with Geophysical Surveys of Bradford, covered a range of topics, from Magnetic and Potential Theory to Artificial Neural Networks. He is now Technical Director of iBase Image Systems Ltd. He published extensively during his Ph.D. thesis, both in the Archaeological and Computing Journals. He has continued this interest at iBase, producing a number of articles for the European and American Image Processing magazines, on systems design and the application of new technology.

William Vaughan is Professor Emeritus of Art History at Birkbeck College, University of London. He has written on Romanticism, on English and German Art of the nineteenth century, and on Humanities Computing. A founding member of CHArt, he has been the Editor-in-Chief of *Computers and the History of Art*, and Chairman of the group from 1985 to 2002. He has been involved in a number of EC projects concerning computers and the visual arts including VASARI and VAN EYCK. His principal publications are *Romanticism and Art* (Thames and Hudson, 2nd ed., 1994) and *German Romantic Painting* (Yale University Press, 2nd ed., 1994). In 1998 he delivered the Paul Mellon Lectures on British Art at the National Gallery London on the theme of *Painting in English: The Making of the British School*.

Annette Ward is currently a Visiting Scholar in the Department of Computer Science at the University of New Mexico, USA, specialising in user interfaces and advanced retrieval techniques. Formerly, she was a Research Associate at the Institute for Image Data Research (IIDR) at the University of Northumbria, UK, where she conducted user evaluations of content-based image retrieval software on sites at the London Guildhall Library and Art Gallery (*Collage*), The British

Library, and the BBC. Current research emphasis includes user evaluation of image retrieval, marketing applications, business/education/non-profit collaborations, and applications of image browsing and retrieval in the textiles and apparel fields.

Suzette Worden joined Curtin University of Technology as Professor of Design in January 2002. Before that she was Reader in Digital Media and Director of Research in the Faculty of Art, Media and Design, University of the West of England, Bristol (UWE). Research projects at UWE included the National Creative Technologies Initiative (NCTI) an AHRB funded project, Digital Arts Curation: Aesthetics, Participation and Diversity. She was Director of CTIAD (Computers in Teaching Initiative – Art and Design) at the University of Brighton from its beginning in early 1996 until March 1998. She has also lectured on the History of Design and has published various articles and contributed to books on women and design, furniture, and product design.

Wlodek Witek is a paper and photograph conservator at the National Library of Norway, Oslo Division. He worked on The Frith Photographic Collection at the Victoria and Albert Museum in London and on Edvard Munch's photographs at the Munch Museum in Oslo before taking up the review of the condition of microfilms and photographs in the University of Oslo Library. He worked on conservation and computer network access to the Fridtjof Nansen Photographic Collection at the University of Oslo Library, and on the multimedia archive of Georg Morgenstierne. He is also a photographer and has exhibited his work in Norway and Poland.

Andrew Zisserman is Professor of Engineering Science at the University of Oxford, and heads the Visual Geometry Group. His research interests include geometry and recognition in Computer Vision. He has published widely in this field and has twice been awarded the IEEE Marr Prize.

Introduction
Digital Art History?

William Vaughan

CHArt has, since its initiation in 1985, set out to promote interaction between the rapidly developing new Information Technology and the study and practice of Art. In recent years it has become increasingly clear that this interaction has led, not just to the provision of new tools for the carrying out of existing practices, but to the evolution of unprecedented activities and modes of thought. It was in recognition of this change that we decided, in 2001 to hold a conference entitled 'Digital Art History' suggesting – perhaps a little ahead of time – a new kind of intellectual fusion. Our intention was to present a challenge and, since this intention was misunderstood by some or our critics, we decided to add a question mark to the title when running our second conference on the theme. That we ran the theme for a second year was a sign of the richness of the positive engagement with it that we found amongst our contributors in the first year. It is quite clear that, among practitioners as opposed to critics, the concept of digital art history is very much a live issue. This is represented in the papers themselves, which we reproduce much as they were presented at the conference, in order that a sense of the constantly evolving nature of digital art history, and the immediacy and even urgency of many of the issues involved can be invoked.

In this collection we have gathered together papers that represent the variety, innovation and richness of the material that was discussed. Some show new methods of teaching being employed, making clear in particular the huge advantages that IT can provide for engaging students in learning and interactive discussion. It also shows how much is to be gained from the flexibility of the digital image – or could be gained if the roadblock of copyright is finally overcome. Others look at the impact on collections and archives, showing exciting ways of using computers to make available information about collections and to provide a new accessibility to archives. The way such material can now be accessed via the Internet has revolutionised the search methods of scholars; but it has also made information available to all. In my teaching I habitually make use of the information provided by such excellent online sites as those of the Tate and the National Portrait Gallery in London – as do my students. However, the new technology is not only about access. It also offers the opportunity for new ways of exploring the structures of images. Indications of this can also be found in papers that deal with the fascinating possibilities offered by digitisation for visual analysis, searching and reconstruction. Most challenging of all are the possibilities offered by digitisation for new art forms. Several papers here look at methods that have been employed. One point that emerges from these is that digital art is not some discrete practice,

separated from other art forms. It is rather an approach that can involve all manner of association with both other art practices and with other forms of presentation and enquiry. Perhaps there is nothing that shows more clearly than these new practices how much we are talking here of a revolution that affects all our activities and not one that simply leads to the establishment of a new discipline to set alongside others.

History of Art in the Digital Age: Problems and Possibilities[1]

William Vaughan

The IT Revolution. Gutenberg Revisited?

There can be little doubt in anyone's mind now that we are in the midst of one of the most dramatic technological transformations in the history of man. Since the establishment of the World Wide Web in the early 1990s, this revolution has affected – both positively and negatively – every society in the world. It has opened up a rich and exciting range of opportunities in the visual arts, as elsewhere – ones that seem to be infinite in their permutations. For many of us the World Wide Web and what it provides are still simply too good to be true. Hardly a day passes without me staring in wonder and disbelief with what I have just brought up on my screen, as I hear outside my window that now all too familiar sound: the beating wings of pigs as they fly by.

In times of dramatic change it is normal enough – after the initial shock – to try and stop and take stock of what is going on. Such surveys cannot, of course, be in any sense definitive, but they can perhaps help us to collect our thoughts and reach firmer decisions about what steps to take next. Having been involved in IT and the Arts in one way or another for more than twenty years I am probably better qualified now for looking backwards than forward. However, I hope that my current paper will end up by being more than a relation of what has happened. I have been involved in a number of projects myself, concerning both visual and textual analysis, teaching initiatives and museum and archive projects. But it is not my intention to give an account here of these. Rather I wish to look more broadly at current practices, and to make some observations, as a user of the rich resources that are now on offer, of the effects that they are having on my own area of expertise – the study of the history of art.

Before going on to consider the ways in which IT is affecting the study, preservation and promotion of art – I would like to step back a little further to take in the nature of the IT revolution itself. In describing this one, a previous upheaval is frequently invoked by commentators. This is the 'Gutenberg Revolution', the establishment in the fifteenth century of the printing press as a means for the mass reproduction of texts and images.[2] This technological advance enabled a new capacity in communication that proved critical for widespread material and intellectual change.

We can see well enough that the IT revolution has brought about an unprecedented access to and interpretation of information. But does this change go so far as to constitute a new mode of thought? The rapid intellectual change summed up in cultural studies by the term 'postmodernism' seems to involve in its own nature that challenge to existing hierarchies that has been at the basis of revolutions in thought, such as that caused, for example, by the 'Copernican Revolution' of the sixteenth century when it was first definitively established that the earth revolved around the sun. This view of the IT explosion as symptomatic of radical intellectual change is certainly supported by the French cultural analyst, Jean-François Lyotard. In *The Postmodern Condition*[3] Lyotard famously sees the IT revolution as an aspect of the change in 'narrative knowledge' that has emerged in the new technological age.

This challenge is certainly evident in changes in our perception of both history and of art. It was as long ago as 1979 that the French artist and philosopher Hervé Fischer proclaimed in a performance in the Pompidou Centre in Paris that the history of art was dead. Fischer claimed that the 'linear' concept of historical progression was now over, a change that affected both our understanding of time and of activities like art that were dependent on it. Now, he claimed, art like history was dead and we were in the age of 'meta-art'.

The proclamation of the death of art has been a familiar avant-garde strategy since at least the early twentieth century. To link this with the death of history, however, was something novel, and reflects the doubts about linear progress that were soon to grow into a crescendo. Ultimately these seemed to be justified by the dramatic political changes around 1990 that brought about the collapse of the communist bloc and the replacement of the dialectical interchange of the Cold War with more mediated forms of discourse. The 'death of history' has now become a commonplace statement amongst cultural analysts, suggesting we are now in a world in which events no longer unfold in a monumental and predictable fashion, and in which none of the old values can be taken for granted.[4]

We can see the impact of this in historical studies generally. 'Classic' studies, in which pride of place was given to 'objective' evidence and to 'leading' areas such as politics and economics, have ceded territory to all manner of investigation and to sometimes bewildering degrees of subjectivity. The history of art has been one of the many branches to be affected. The concept of history as a progression of styles orchestrated by Great Masters – has given way to a questioning of aesthetic canons and to the very notion of artistic development. It is significant from this point of view that the schools and departments that teach the subject in the United Kingdom are now increasingly changing their titles from 'History of Art' to 'Visual Culture' – a term that simultaneously obviates both history and art, replacing these with a temporally unspecific and aesthetically non-discriminatory exploration of the pictorial.

This change in academic practice is evident enough. But are we in fact dealing with a phenomenon that has any application beyond that rarefied world? Are we talking

here of no more than an 'Ivory Tower' revolution? We are told that history is 'dead', a victim of the new perception of time as multi-layered and multi-dimensional. Yet events still seem to unfold in this 'post-historical' world in a sequential manner as they did before, and to be susceptible to very much the same kinds of description and analysis. We are told that art is 'dead' and that now all forms of visual manifestation should be of equal interest. But this does not seem to stop the public flocking to the old guardians of outmoded aesthetic values such as the Uffizi, the Louvre and London's National Gallery. In fact they come in increasing numbers. Nor does visual culture's exposure of the myth of the 'masterpiece' seem to have put a dent in the auction houses' habit of selling these discredited items for countless millions.

It may turn out in time that the 'revolutions' in thought that we have experienced are less Copernican than they might at first seem. But perhaps we are simply too close to what is happening to understand it. What we can do, however, is to describe the visible symptoms of change, hoping thereby to build up in time a fuller picture of what is happening.

In the following sections of this paper I shall look at some of the symptoms that seem to me to be most telling, particularly in relation to the study of works of art.

Information and Knowledge

I will start with a general issue – that of the nature of the experience we gain via IT. I would argue that the new IT process foregrounds information over knowledge. The latter is a long-term process, conceptualised within the mind. Information is a form of short statement that can be delivered easily by automated processes. The gathering of information becomes much easier by these means. It remains an open question about whether this change is actually driven by the new technical processes, or whether those processes are themselves a symptom of a deeper cultural transformation. We are constantly being made aware of the increasing shortness of our attention span, and the ways in which this seems to be related to the diversions of a consumerist society. It would appear that we prefer, nowadays, the short reports offered in journals and newspapers to the long distance reading required by novels and scholarly investigations. Similarly the process of spending hours in the company of a single image is replaced by a practice that expects the stimulus of continual visual transformation. Reading books on screen is becoming more common – but is still not easy for most of us. The ability of IT to fragment large works – for example the potential offered by DVD to subdivide film narratives into sections – offers a quite different way of approaching texts, both visual and aural. This could lead in time to them being reduced to a mass of information, explorable through all kinds of analytical processes but never appreciated, as they once were, as a totality.

Art and the Digital Image

This practice of fragmentation extends to the digital image. The very process involved in its construction represents pictorial continuity as a series of distinct units, even when these are perceived by the spectator as an integrated whole. It should be remembered in this context that a digital image is not a 'reproduction' in the way that an analogue image is. Rather it is a transformation of an image, a translation from a continuum to a set of discrete units. When displayed on a screen the image is re-performed according to a set of encoded instructions.

The physical means of display encourage a fragmentary approach. The limited definition offered by most screens restricts quality, encouraging this process of fragmentation in the way we look at them. The 'whole' reproduction of a work offered on the screen is usually a schematic mnemonic, put up as a guide for the spectator. It is only the individual details that can be provided in anything approaching their actual quality. Such processes can perform brilliantly for certain types of technical analysis, for example those required in conservation processes. But they do raise real questions when it comes to the issue of offering a surrogate for the experience of a traditional work of art.

As screen sizes increase, making possible larger and more detailed visual representations, it may be that this problem will diminish. Nevertheless, I suspect that the temptation to explore the fragment rather than absorb the whole will persist.

Quality and the Aura

Digital imagery opens up a new a point of entry into the debate surrounding the issue of the 'aura' of the unique work of art – that quality famously identified by Walter Benjamin in his essay *The Work of Art in the Age of Mechanical Reproduction*.[5] Much attention has been focused on the notion that the 'aura' of a work of art is related to its 'uniqueness'. The digital image can present a challenge to such claims in two ways. First, it is by its very nature infinitely reproducible. Indeed it is nothing but reproduction. There is, literally, no original of a digital image, since every version has equal status by virtue of being absolutely identical. Variation does occur in practice, but only at the point where the image is performed, as the performance is dependent upon the character of the apparatus displaying it. Even here, however, there is no sequential hierarchy. Each performance has an equal relationship to the code on which it is based. The 'quality' of the performance is entirely dependent upon the apparatus used for display – just as the 'quality' of a piece of music performed is dependent upon the skill of the musicians performing it. The second challenge is also dependent on this performative nature. The digital image is a 'passive' reproduction in the way that photographic copying is. It can therefore be creative in its interpretation, fragmenting and analysing as well as reproducing. Yet there are questions about how much these implications can as yet be fully accepted. It seems significant that

while contemporary artists incorporate the digital into their work, the production of pure digital art remains a minority activity. I suspect that it is the very lack of uniqueness that hampers development here, in an art world geared to reward individuality above all other criteria.

Opportunities

When looking at the opportunities offered, then one turns almost inevitably back to the question of information. How much easier is it now to access information! A single keyword typed in to a search engine like Google (but let us face it, there is actually *no* search engine like Google when it comes to quality of performance) can deliver a cornucopia within milliseconds. Yet we all know too that such information can be highly different in quality. Ironically it is the knowledgeable person who gains most here, since scholarly practice familiarised him or her with the process of sifting and critically evaluating large bodies of information. Even such seasoned explorers, however, give up thanks for the increasing number of sites compiling accurate well-researched material. In the visual arts there are textual indicators as there are for other historical studies – such as the Inventory of Artists Papers in the UK.[6] As yet there are far too few actual art texts available online – something that contrasts strongly with historical and literary studies. I have myself been involved in recent years in putting up Hogarth's *Analysis of Beauty* – which is viewable on the Birkbeck College website.[7] I do hope that art historians will join in making more and more classic texts available online – particularly those that are not readily available these days in modern editions. But the key area for the visual arts is of course the visual archive. Here we have seen great strides in recent years, both in collections making their images available online – such as the Tate Gallery in London which has a full text listing of their holdings and the vast majority of its images.[8] Equally impressive are those collections put together by consortia of museums, such as the American group AMICO.[9] While the Tate website is free, AMICO make a charge – though one that seems to me to be a highly reasonable one. Yet this does lead to other benefits. While the quality of reproductions on the Tate website is limited to that which is useful only as a screen display, AMICO give you images that can be useful for more thorough exploration. The quality of information provided, too, is far more scholarly than that given by the Tate, which is aimed more at a general public. There are also equally important virtual collections, such as that of the Corpus Vitrearum Medii Aevi.[10] This aims to give a comprehensive and international inventory of medieval stained glass windows (an art form, incidentally, uniquely well suited for screen display because of its transparency). While the information provided by the Tate is limited, this shows the highest scholarly standards. Such a work will surely in time render the printed catalogue *raisonné* obsolete – the more so since the online catalogue can be instantly updated.

All this is heartening, but there does, perhaps, remain one unsettling question in connection with such projects. This is the question of durability. In theory the digital image has an indefinite life. The code that creates it does not decay.

However, such code is dependent for its survival and communicability on the electronic processes that store it and perform it. How reliable are such processes? An Egyptian hieroglyph, carved on a wall or even inscribed on a parchment scroll remains readable to this day, thousands of years after it was made. How long will a digital record last? When our civilization follows the course of all previous ones and meets its end (either by catastrophe or decay), how will it be possible for future beings to gain any kind of access to the information that we have been storing in our idiosyncratic and highly vulnerable machines? There may be an answer to this question, but it is unlikely that we will be around to find out what it is.

To the opportunities for documentation can be added those of new forms of presentation. 'Virtual' exhibitions mushroom. Sometimes these are surrogates for the real thing. One example is the National Museum of Uruguay, which exists as yet only as a website.[11] In this website we are given a virtual tour of the building that Uruguayans hope will one day be built. In the meantime they can still make us aware of the work of their leading artists via the website. The simulation of the museum visit on this site is perhaps important because it helps to confirm a 'museum' status on the works that are looked at digitally. Elsewhere, however, the simulation of the museum visit can be dispensed with and other issues can be stressed. A good example of a thematic virtual exhibition is *Painting the Weather,* mounted in 2001 by the National Gallery in London and sponsored by the BBC.[12] This explored representations of the weather in art by means of showing images of pictures from collections throughout the British Isles. This might simply be seen as an exhibition on the cheap, but there was a further point being made. Not only did it engage the spectator in a particular theme, but it was also a means of raising consciousness about the works of art on display in provincial museums that are all too little visited. Visitors to the site were made aware of the actual location of each work reproduced and encouraged to look at it there.

The increasing access to imagery provided by the web has also led to the growth of the teaching of history of art via the web. A splendid example of this has been provided by Britt Kroepelien in her account of the courses for History of Art that she has developed at the University of Bergen for online teaching throughout Norway.[13]

Problems: Ownership and Copyright

Kroepelien's success in mounting her course may have led to envious eyes from colleagues in many countries. Her project received strong government funding, which enabled her to deal with one of the most enduring problems facing those in Britain wishing to teach using digital imagery. I refer, of course, to the problem of copyright. Perhaps this problem is now being overcome in most countries at the teaching level. Yet in Britain there is still no security offered, and the current copyright law is vicious in its implications. This means in practice that institutions have no affordable means of dealing with copyright and do not on the whole want to run the risk of infringing a law whose implications have as yet not properly been

tested. The absurdity of the situation is that many private individuals make personal use of the huge wealth of imagery available to them via the web – or simply by the process of photographing or scanning reproductions, while not being able to use such material in a teaching situation. Recently I tested this absurdity by deciding to take two routes to gain a reproduction of a famous Scottish painting, the one of the Reverend Walker skating (familiarly known as the *Skating Minister*) by Raeburn. Knowing it was housed in the National Gallery of Scotland, I went to that institution's website. Only the tiniest of thumbnails of the picture was available, despite the fact that it has been adopted as a logo by the institution as a whole. Knowing, too, that the National Gallery of Scotland was a member of SCRAN, the consortium of Scottish Museums that make information available at a charge for teachers, I visited that site where, after searching through their database structure – a process that took some minutes, I finally came across the picture I wanted.[14] That was the 'correct' thing to do – but even that was only possible to me because my institution happened to have signed up to SCRAN and was paying the consortium an annual subscription. However while pursuing this virtuous path, I was all too aware of the temptation to fall into vice and use the alternative – namely an image search on Google. And in fact, an image search on Google, using only the keywords 'Raeburn skating' instantaneously provided me with examples of not one but over forty reproductions of the skating vicar, many of which were equal in quality to the image being offered via SCRAN. In view of such circumstances, it is no wonder that image bootlegging is the order of the day. But however satisfactory such illicit image usage is for the private individual, it still begs the question of when a fair system for the public use of images in teaching and research will come into being.

Problems of Analysis and Interpretation – Iconography and Classification

So far I have been looking at the acquisition of information via IT. But what about the possibilities of analysis and interpretation? This still remains one of the most disputed areas in IT. Even nowadays there are differing voices about the possibilities offered by artificial intelligence, expert systems and similar forms of analysis. In the visual arts this issue focuses upon the problem of how far an image can be analysed by computational means. We all know that there are specific forms that can be described and identified, and that such search possibilities have been widely used in scientific analysis, for example to identify different kinds of cells in clinical analyses which can be of great value in medical diagnoses or in the codification of the forms that will allow the automated processing of fingerprints or DNA samples. When we come to forms as complex as the visual image however, it seems as though the complexity multiplies beyond the possible. There are, it is true, some areas of design where specific formal characteristics can be identified. Computers have been used, for example, to identify certain types of furniture or spoons or drinking vessels. In all cases where the results have been effective there have been forms of sufficient rigidity and regularity to enable codified matching to take place. There are indeed forms within pictures that have such regularity. Face

recognition – which has been used and which functions on the fact that the human face has sufficient regularity and predictability in its forms to enable identification – could be applied in pictures. Yet the problems of setting this up would be too complex probably to justify the returns.

Another approach is to take existing forms of image analysis and attempt to apply them to computers. As elsewhere this process is a testing one that leads often to the clear demonstration of differences of forms. Attempts have been made, for example, to codify the iconological system that was constructed by Panofsky for classifying the differing levels of meaning in an image. Yet as far as I know, this imaginative structure had proved too complex and elusive to ever lead to a systematic application. Panofsky's imaginative construct was, like so many structural systems created for the purposes of cultural analysis, more of a conceptual than actual model, and as such it is not really susceptible to mechanical application. A different situation is the one presented by literal iconographical systems. The most notable success here has been the use of the codification system ICONCLASS.[15] Unlike Panofsky's iconological model, ICONCLASS does not seek to organise layers of meaning. Rather it seeks more simply to assign a specific code for each element of meaning within a work. The directness of this approach – as well as the hierarchical order in which such elements are ranged – makes the assignment process achievable – although this has to be done via the input of specialists rather than by automated means. Nevertheless, the resultant outcome is a structure of information that can be entered into a database and that can lead to all the rewards that database structuring allows. ICONCLASS classification systems are now regularly being used where collections of iconographically oriented imagery exist. Yet while straightforward in one sense, ICONCLASS and similar classification systems also throw up fascinating complexities. It should be stressed that ICONCLASS does not provide a unique identifier for a specific picture. What it does is classify a specific subject visible within a picture. The same picture can in fact bear an almost inexhaustible number of ICONCLASS code identifiers, depending on the interests of the classifier. To quote a specific example, Reynolds' portrait of Kitty Fisher as Cleopatra could have one ICONCLASS identifier as a portrait and another identifier as a representation of a subject from classical antiquity.[16] It could also be identified with reference to costume or jewellery. Subject and image have an independence of each other, something that would make little sense in terms of a Panofskian exploration of specific meaning. Yet nobody could deny the practical use of ICONCLASS as an encodable system of identification – albeit one that aids that fragmentation of knowledge into information that I mentioned earlier on.

It may also be possible to use a formal codification of pictures to analyse and relate compositional forms. As yet work in this area remains unproved, though the evidence provided by the practical application of processes that encode the structure of the image via digitisation are encouraging. Recently the University of Northumbria have been applying the VIR search system from Virage® to the collection of the Guildhall in London, with encouraging results.[17] Earlier, I myself was involved in a system used in connection with the VAN EYCK project, a project

that unfortunately has not reached fruition. Yet I feel enough was done there, too, to show how effective simple form matching can be.[18] The mistake – in my view – with those criticising form analysis – has been to expect it to answer highly specific cultural related questions rather than to see it as the kind of visual equivalent of word searching. Once people have got over the fact that high cultural searching of images via the computer is unlikely it may be possible to make the kind of progress with simple form searching that has been achieved so spectacularly with word searching already.

The User's Share

This thought brings me to the final point that I wish to make about the computer. This is that it has only developed in the way that it has through the significant input of the user. The computer was invented by scientists and in its early days it looked as though it would remain the machine controlled by men in white coats, controlling all with their arcane knowledge. But this was never the vision of Turing, the British inventor of the computer. He always saw it as the 'universal transformation' engine.[19] The transformations that it can achieve depend on what is asked of it. The whole history of IT has in fact been that of a tug of war between the scientist specialist and the amateur enthusiast. Or perhaps more importantly, between science and commerce. The original creators of computer systems were happy enough to speak to their machines in highly complex machine code. It was business demand that turned it into the engine that could be manipulated by all in the office, and then in the home. The Internet was invented by a British physicist seeking a way of communicating more complex material to his colleagues world wide than that which could be sent by text emails.[20] Yet this new graphic environment rapidly moved from being a domain run by physicists to the universal communication system that it is today, which has become absolutely central to all forms of commercial transaction. That was never the intention of its inventor. It was other pressures that caused this development. Those who make no demands of the computer will receive no benefit. It is up to all of us to make demands, to press for what we think it will be possible for it to do. IT is far too important a resource to be left in the hands of experts. But what this history has shown is that both enthusiast and expert are needed. What we have now is the product of their struggle, and more so, of the creative solutions that have come out of their engagement. Without 'consumer' demand there would never have been the PC or the huge number of products. The web came out of the demands of a user group. It was unsuspected commercial potential that then caused it to spread.

The main message is flexibility. This, in the end, is the difference between Gutenberg and the IT revolution. Gutenberg brought in reproducibility – but it was inflexible reproducibility. The book, once printed, cannot be changed. It can only be refuted. The website can be updated every second. And when it is updated the older version disappears – not like the book, which lies in libraries still proclaiming the same old message, irrespective of what has happened since. The book is one of the greatest of all human inventions and one that will, I hope, last as

long as mankind does. But alongside its incomparable role in preserving deathless works of art and intellect, it has been used, in the past, to lend a seemingly absolute authority to much that does not merit it. In the wrong hands it can become the servant of those inflexible, predictive theories of history that hopefully now have come to the end of their ascendancy. Nobody would predict with confidence nowadays what the situation will be like in even five years time from now. All that we know, is that things – both great and small – will be different. Art will be different, and so will its history.

Notes

1 This paper is an expanded and revised version of a text published in the proceedings of the EVA Conference *Electronic Imaging and the Visual Arts*, 25 July 2002, Imperial College, London, pp. 1.1-5. It is also available online in *zeitenblicke* 2 (2003), Nr. 1 [8 May 2003], www.zeitenblicke.historicum.net/2003/01/vaughan/ index.html (active 21 July 2003).

2 The classic text that spearheaded the rethinking of Gutenberg was Marshall McLuhan's *The Gutenberg Galaxy*, Toronto, 1962. It was McLuhan's contention that modern technology (which he at that time identified more in terms of television than the computer) was about to explode linear forms of thinking that had been established by the Gutenberg revolution. More recent voices have both identified the computer as the more potent agent of such change, as well as querying the ways in which this operates. See for example Umberto Eco's lecture *From Internet to Gutenberg*, 12 November 1996, www.hf.ntnu.no/anv/Finnbo/tekster/Eco/Internet.htm (active 21 July 2003).

3 Lyotard, J. F. (1979), *The Postmodern Condition*, Manchester University Press.

4 Fischer, H. (1981), *L'histoire de l'art est terminée*, Paris: Balland.

5 Benjamin, W. (1936), 'The Work of Art in the Age of Mechanical Reproduction,' (trans. H. Zohn), in Dayton, E. (ed.), *Art and Interpretation,* Peterborough: Broadview, 1988.

6 Artists Papers Register, www.hmc.gov.uk/artists (active 21 July 2003).

7 www.bbk.ac.uk/hafvm/hogarth/index.html (active 21 July 2003). From this I have become all too aware of the huge labour involved in such a project. While we have the full text up now, we are still building the related notes and images.

8 www.tate.org.uk/collections/collection_search_simple.jsp?group=general (active 21 July 2003). The only images not included are those restricted by artists' copyrights.

9 The Art Museum Image Consortium, www.amico.org (active 21 July 2003).

10 Corpus Vitrearum Medii Aevi, www.cvma.ac.uk (active 21 July 2003).

11 Museo virtual de artes el pais, www.elpais.com.uy/muva2 (active 21 July 2003).

12 www.bbc.co.uk/paintingtheweather/ (active 21 July 2003).

13 Kroepelien, B. (2003), 'E-learning – an approach to teaching art history in the Internet age', *zeitenblicke* 2: 1, Digitale und digitalisierte Kunstgeschichte Perspektiven einer Geisteswissenschaft im Zeitalter der Virtualität, Kwastek, K. and Kohle, H. (eds.), www.zeitenblicke.historicum.net/2003/01/index.html (active 21 July 2003).

14 Scottish Cultural Resources Access Network, www.scran.ac.uk (active 21 July 2003).

15 www.iconclass.nl/libertas (active 21 July 2003). The project is run from the University of Utrecht. Amongst other facilities there is an online index to classification provided.

16 Sir Joshua Reynolds, Kitty Fisher as Cleopatra (1760, oil, Kenwood House, London). For a discussion of problems of classification see Gordon, C. (1992), 'Dealing with Variable Truth; The Witt Computer Index', *Computers and the History of Art Journal*, 2: 1, pp. 21-8.

17 See Ward, A. A. *et al.*, 'Enhancing a Historical Digital Art Collection: Evaluation of Content-Based Image Retrieval on *Collage*', in this volume and at www.chart.ac.uk. The *Collage* website is at http://collage.cityoflondon.gov.uk (both active 21 July 2003).

18 Vaughan, W. (1985), 'Automated Connoisseur: Image Analysis and Art History', Denley, P. and Hopkins, D. (eds.), *History and Computing*, Manchester, pp. 215-222; Vaughan, W. (1992), 'Automated Picture Referencing; A Further look at "Morelli"', *Computers and the History of Art Journal*, 2: 2, pp. 7-18.

19 For Alan Turing see the Turing home page, www.turing.org.uk/turing/ (active 21 July 2003).

20 Berners-Lee, T. (1999), *Weaving the Web*, San Francisco: Harpers.

Animating Art History: Digital Ways of Studying Colour in Abstract Art

Mary Pearce

Introduction

This paper focuses on the advantages of new media in presenting art historical educational material in a stimulating and accessible way. Throughout the explanation I will draw specifically on examples from an interactive[1] CD-ROM entitled *Colour and Communication in 20th-Century Abstract Art* that was created as part of my Ph.D. research, undertaken through Kingston University.[2] It is intended for educational use in museums, as an extension to digital archives, e-learning or as a tool for teachers in the classroom. Before beginning the research I had been involved in both commercial and artistic projects in Britain and Brazil and was able to draw upon techniques used for commercial CD-ROMs adapting them towards defending an art historical thesis. The CD-ROM presentation is set in the period of twentieth-century Western art, starting with the influence of nineteenth-century colour theory on the early twentieth-century European painters and demonstrating the manner in which the change in the role of colour progressed in parallel with the development of abstract art. As will be evident, I used a subject matter that suited the medium in order to experiment with the potential of multimedia.

Since making the CD-ROM I have been given the opportunity to develop some of my ideas in e-learning situations especially at an institution called 'Escola do Futuro', the 'School of the Future',[3] based at the University of Sao Paulo in Brazil. Here I have been creating small educational modules or 'learning objects' on colour and music under the umbrella title of *A Magia da Cor* (The Enchantment of Colour) to be published in their virtual library. The virtual library makes available archive material such as literature, Brazilian music, free software and materials for teachers, to remote areas of the country and to Portuguese speakers worldwide.

In this paper however, I would like to concentrate on the original form of my CD-ROM because it represents a complete statement and its architecture was planned to hold together many interrelated facets which, after all is one of the most well-known advantages of this medium. In the course of my research several enquiries were made with regard to the suitability of new media for an art historical survey

and I stress that one of the major preoccupations was always to experiment with this possibility to enhance the study of art history. The main aim of the paper is, therefore, to draw on my own research to suggest some advantages multimedia might have for the study of Art History in the digital era. I therefore start by outlining the rationale behind the architecture of the CD-ROM, which demonstrates the possibilities for cross-referencing analytical and historical issues of Art History. Then I describe some analytical sections, suggesting some of the advantages of multimedia as an educational tool. For the purposes of continuity and clarity, throughout this paper I use examples of Paul Klee's paintings rather than those of other artists discussed within the CD-ROM.

1. Suitability of New Media to the Study of Art History

Synthesis of Many Themes Presented in One Didactic Tool

The focus of the CD-ROM presentation is not only on a general survey of chromatic values within the composition of paintings, but on comparing the significance of colour in twentieth-century paintings from three distinct eras of Western Modernism, including examples of the work of Orphist, Bauhaus and Abstract Expressionist artists.

In addition to this, a central feature of research into the way that colour is understood within these movements relies on a synthesis of themes which associate colour with interpretations of music, calligraphy, visual poetry and issues of time and space, with reference to their individual roles and inter-relationships within the compositions of the paintings. However, synthesis also has a particular significance for both the content and the use of multimedia as an innovative means of presenting these complex concepts and it is, furthermore, in keeping with the methodology of the painters described within the CD-ROM presentation, that multimedia are used to demonstrate the themes mentioned above. The reason for this is that various artists in the first two decades of the twentieth century, including those affiliated to the Blue Rider movement, aimed to create a 'total' artwork (*Gesamtkunstwerk*) that brought together many creative disciplines and was not confined by the conventional boundaries of media.[4] In general, these artists felt that the more senses that a work could appeal to, the better the chance of touching the imagination or 'inner spirituality' of the spectator.

The idea of 'synthesis', therefore, appears in various permutations throughout the eras discussed: for example, as 'simultaneity' within the work of the French artists, Robert and Sonia Delaunay; as a 'total art' in, for example, the 'Polyphonic' paintings of Paul Klee, and as 'absolute art' in the work of some of the American Abstract Expressionists, such as Barnett Newman or Mark Rothko.[5] Given that all of these descriptions have relevance to the reading of colour within Western Modernist painting, it was felt to be important to give the user the opportunity to acquire an understanding of the visual grammar that was at play within the

composition of the works. An introductory section was therefore included to define the general technical qualities of colour as part of a visual language.

In extending the phenomenon of synthesis within a 'total' art, by discussing it through the added dimensions of digital multimedia, I was first adding new possibilities to the idea of mixed media artistic productions, such as those favoured by the above mentioned artistic movements. Second, I was also using that very medium of digital multimedia, to address the limitations of a traditional linear art-historical survey. The subject of colour with relation to the painting movements is, therefore, especially suitable for a multi-dimensional presentation of this sort.

Explaining Visual Phenomena Through Visual Means – Accessibility of the Medium

Digital multimedia represent an accessible way to introduce some of the features inherent in abstract art, which are notoriously difficult for some gallery visitors to understand. As mentioned, the reasoning behind the transition of colour from being a figurative surface feature to having meaning as an element of an abstract composition in its own right, is complex and grasping this reasoning depends, to a large extent, on understanding some of the fundamental concepts about both colour and abstract painting. However, the information on colour theories may be easily explained through graphic exercises that focus on visual perception. Throughout this research, therefore, there has been a preoccupation with finding a means of interpreting complex ideas in a visual way, to make them more easily assimilated by a general public.

Consequently, much of the CD-ROM presents sections which enable the user to grasp the many interpretations of tone, tint and hue, by controlling on-screen events which physically reveal the differences between these elements of colour. These sections are the basic introduction or 'Primer', 'Tint', 'Tone and Hue', and the 'Perspective of Colour'. The intensive use of written text was avoided within the screens themselves and instead animation and audio-visual means were utilised to convey the issues through the direct communication that colour can have on the senses.

In the section 'Tint, Tone and Hue', for example, the user can place the cursor over buttons of individual colours and a central area of graduated greys, ranging between black and white, will transform into gradations of the particular hue chosen by the user, so the distinction between tints and tones are easily recognised (Fig. 1B).

Similarly, the section 'Perspective of Colour' demonstrates, through a sequence of screens, that colour does not need to be contained as a surface feature of three-dimensional objects in order to represent dimension on the picture plane. In a pop-up window, an animated sequence of transforming screens is available, which succinctly trace the development of Mondrian's compositions into abstraction,

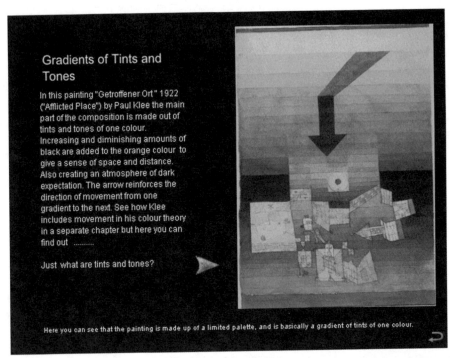

Gradients of Tints and Tones

In this painting "Getroffener Ort" 1922 ("Afflicted Place") by Paul Klee the main part of the composition is made out of tints and tones of one colour. Increasing and diminishing amounts of black are added to the orange colour to give a sense of space and distance. Also creating an atmosphere of dark expectation. The arrow reinforces the direction of movement from one gradient to the next. See how Klee includes movement in his colour theory in a separate chapter but here you can find out

Just what are tints and tones?

Here you can see that the painting is made up of a limited palette, and is basically a gradient of tints of one colour.

Fig. 1. (A) Sections open with an image of a completed painting where the technique is employed.

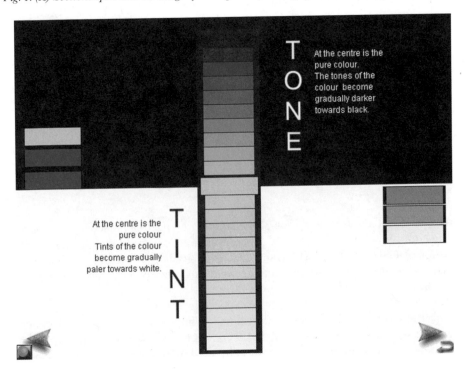

T O N E

At the centre is the pure colour. The tones of the colour become gradually darker towards black.

At the centre is the pure colour Tints of the colour become gradually paler towards white.

T I N T

(B) Introduction to 'Use of Tonal Gradations'. Difference between tints and tones.

adding a wider significance to the role of abstract colour by emphasising the fact that the painters discussed in more detail in the presentation, were not alone in their interpretations of colour.

Thus, the possibility of using sequences of screens, analytical animations and illustrated graphical flow charts can be developed into a new kind of educational tool, which approaches the analysis of paintings through user participation, explaining visual phenomena through visual means.

Focus on the Spectator/User. The 'Reading' of the Composition as a Temporal Process

Other sections focus on how the perception of these qualities of colour is important for the reading of the picture, whether this understanding be intuitive or intellectual. For example, the focus on the process of the painter revealed in 'Movement – Tracing the Artist' draws on examples of two paintings by Paul Klee entitled *Fugue in Red* and *Growth of Nocturnal Plants* (*Wachstum der Nachtpflanzen*, 1922, Galerie Stangl, Munich) and is intended to demonstrate two main ideas. First, the representation of time in the painting, where colour could be set up in rhythms which lead the attention of the spectator in a temporal flow from one area to another within the composition. Second, that the process through which the artist builds the picture is visible in the end result. Both of these concepts were relevant to the earlier work of Sonia and Robert Delaunay[6] and are relevant again to the later work of the American painters, where the intention is to assist the user in the understanding the process of Action Painting, where the action, or gesture, of the painter is recorded on the canvas (as mentioned below in 'Development towards Web Publication'). Navigational links are therefore set up between these sections.

Therefore not only 'synthesis' has further significance within the work of the two eras but the user of the multimedia becomes aware of the temporal rhythms within the seemingly static medium of painting. In this way, the participation of the spectator when viewing a painting, which was crucial to the conception of the various artists discussed within the CD-ROM, is developed within the interactive medium.

2. Organisation of Material

In the previous section I have discussed how, through using multimedia, it was possible to create a structure that was tightly interrelated – that would represent the multiplicity of ideas set in balance. The information presented would neither be purely formal, in terms of demonstrating chromatic relationships in the paintings, nor would it be limited to the representation of any one particular colour theory, but it would be a combination of formal, historical and theoretical data that would introduce the user to methods of perceiving paintings with a capacity for

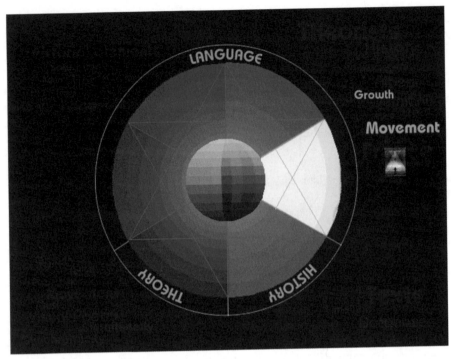

Fig. 2. Main menu. (A) Highlighting one section.

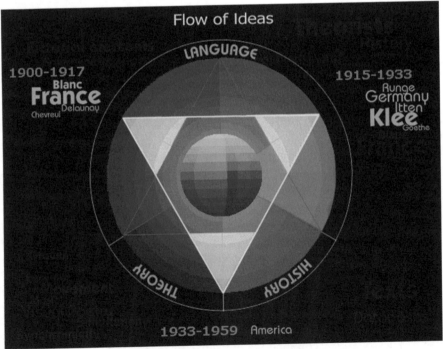

(B) Highlighting the centre: three historical eras in France, Germany and America.

wider reference. Organising all this material within one study required a plan of various dimensions (Fig. 2).

The Main Menu – Overall Architecture

The most important manifestation of the architecture is in the main menu. It appears after an introduction to the period of Western art at the beginning of the century. To mark the fact that this was a time when both music and the visual arts were going through changes in structure, the music of Stravinsky's *Rite of Spring*, 1913[7] can be heard as the text appears on the screen.

The main menu is based on a flow chart (available in other areas of the CD-ROM) which has been adapted to a graphical navigational field. The overall choice of graphic design for the navigational interface, where aspects of the colour wheel were chosen to represent the separate sections, was inspired by David Siegel's concept in his book *Creating Killer Websites* which suggests the use of an 'umbrella' metaphor for the purposes of navigating websites.[8]

The information is divided into three main categories, 'Language of Colour', 'Historical Background' and 'Theoretical Background', and although these are interrelated, distinction is established between ways of approaching the paintings themselves.

Each of the three main categories is divided into many other subsections, most of which open with a painting as a starting point, to be analysed with relation to the individual topic in discussion. For example, the section describing tones and tints, mentioned earlier, opens with a painting by Paul Klee called *Afflicted Place* (*Getroffener Ort*, 1922) which demonstrates the technique of gradations of one colour (Fig. 1A).

Thus within the subsections of 'Language', the users gain insight into the significance of specific qualities of colour within a composition. However, since this use inevitably bears relation to wider historical and theoretical issues, other sections are devoted to broadening the discussion of the chosen painting.

In contrast, the three subsections of 'Historical Background' entitled 'Flow of Ideas', where the main argument of the thesis is housed, open with an introductory animation which pinpoints the main criteria typifying the artistic production of the era.

Gradients of Tone can be interpreted as musical scales and subsequently as NUMBERS.

In order to get a sense of balance you can begin to do mathematics with the numbers...........

TONES

| 1 |
| 2 |
| 3 |
| 4 |
| 5 |
| 6 |
| 7 |
| 8 |
| 9 |
| 10 |

4

4 8

For example:

$$4 + 4 = 8$$

Therefore TWO equal quantities of the tone 4 will equal one of the tone 8

Fig. 3. Turning a sequence of numbers into weights of tone and musical analogies. (A) The numerical harmonies as a method of weighing colours for distribution in the painting composition.

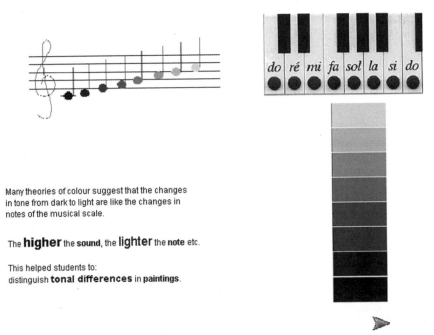

Many theories of colour suggest that the changes in tone from dark to light are like the changes in notes of the musical scale.

The **higher** the sound, the **lighter** the note etc.

This helped students to:
distinguish **tonal differences** in paintings.

(B) Range of tones as musical scales. The user passes the cursor over the notes to create a tune and see tones.

Creating HARMONY by NUMERICAL BALANCE

Roll the cursor over the square to see the numbers converted into tones

The way of **working out a balanced composition** was to create a square with numbers in it so that whichever way you add up a line it will always total the same.

Here for example:
Every line, if added horizontally or vertically **will always add up to 15:**

3	1	5	4	2
2	3	2	2	6
4	2	4	2	3
1	7	1	3	3
5	2	3	4	1

$$3 + 1 + 5 + 4 + 2 = 15$$
$$+ \quad + \quad + \quad + \quad +$$
$$2 + 3 + 2 + 2 + 6 = 15$$
$$+ \quad + \quad + \quad + \quad +$$
$$4 + 2 + 4 + 2 + 3 = 15$$
$$+ \quad + \quad + \quad + \quad +$$
$$1 + 7 + 1 + 3 + 3 = 15$$
$$+ \quad + \quad + \quad + \quad +$$
$$5 + 2 + 3 + 4 + 1 = 15$$

$$\overline{15} \ \overline{15} \ \overline{15} \ \overline{15} \ \overline{15}$$

clear square

Fig. 4. Turning a sequence of numbers into a balanced tonal composition. (A) The numerical harmonies as described by Paul Klee.

The time element of music is trapped on the Canvas Harmony is achieved through BALANCE.

In this way :

The **areas of dark tone** would be **balanced** by **larger** areas of **lighter tone** .

The composition would not become too dark or too light but would have a good dispersal of dark and light tones.

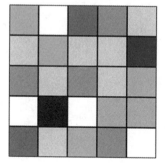

The fact that the rows both vertically and horizontally needed to sum up an equal number (here 15) ensures that where there is area with a very dark tone (i.e. one which has the number seven) the rest of the squares around it would have to be very much lighter (lower numbers) otherwise the addition of the numbers would be too great. These darker areas are like areas of intensity which must be balanced by less intense surroundings.

(B) The same numerical code converted into a range of tones. The user passes the cursor over the numbers to complete the conversion.

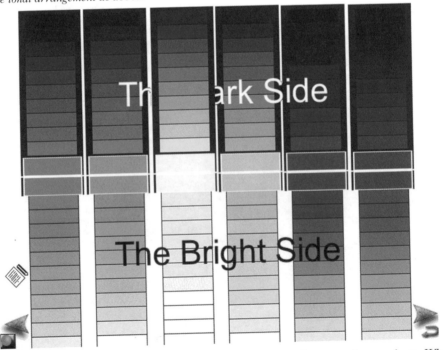

The composition remains HARMONIC if EACH COLOUR IS SELECTED FOR ITS TONAL QUALITY.

Just as with the composition of tints, if this were converted to white and black it would have the same tonal value as the original black and white drawing.

3	1	5	4	2
2	3	2	2	6
4	2	4	2	3
1	7	1	3	3
5	2	3	4	1

7
6
5
4
3
2
1

As painters and students at the Bauhaus became more skilled at distinguishing the tonal value of colours they could **mix different hues and saturations of colours for every tone**.

Fig. 5. Every colour, even a pure one, has a tonal value. (A) Substituting pure colours within the same tonal arrangement as above.

Th[e] [D]ark Side

The Bright Side

(B) Screen shot from another section explaining tints and tones of a range of pure colours. When the user places the cursor over one of the centre colours, the black and white gradient fills with the tones and tints of that colour. It is also possible to see that, for example, the full tonal range of yellow is lighter than that of blue. (Relevant to 5A).

The Subsections

Learning Methods – A Change in the Didactic Process

Each of the subsections was intended to be a self-contained unit, but, though it is possible to enter the sections in chronological order, the sequence of entry is not fixed as the learning process can be cumulative. This is a further consequence of the reasoning that a full understanding of the subject requires cross-referencing formal qualities with different theoretical angles presented.

A teacher would have freedom, therefore, to draw on the sections to develop a particular technical feature with reference to the paintings. Below I discuss two usages in more detail, with relation to possible advantages within a classroom or other didactic situation.

The first example demonstrates how a teacher can use multimedia as a tool for more detailed analysis and the second demonstrates an instance where the medium is useful for the demonstration of synthesis, or the co-relationships present in one composition (Figs. 3-5).

Example of the Use of Multimedia as Tools for More Detailed Analysis

In the following example, the medium proves advantageous in the close analysis of paintings with relation to any one in particular of the technical qualities of colour.

Developing the same example as previously, after the distinction between tint and tone has been perceived, a teacher could draw attention to the different application of this technique within compositions. For example, the concept of gradation of tones could be seen as significant in the Klee painting *Eros* (1923, watercolour, Rosengart Collection, Lucerne), where, in combination with progressive layers of translucent paint, it represents the ephemeral qualities of transience and change, and is aligned with concepts from Goethe's *Theory of Colours* (Fig. 6). Yet it is evident that a similar use of tone may be applied in another way, with relation to parallels with musical tone. Here, in combination with qualities such as opacity, translucency, contrast and optical mixing, the numerical games are translated as tonal combinations on a chessboard format to create harmonic compositions (Figs. 3-5). This can also be explored further with relation to Paul Klee's polyphonic painting.

The middle period, the 'German Section (1915-1933)', was chosen as the foundation of the more detailed analysis of any one of the overall themes. Paul Klee left many notes and sketches that demonstrate the thinking process behind his final compositions, these additional sources are 'readable' as a set of visual

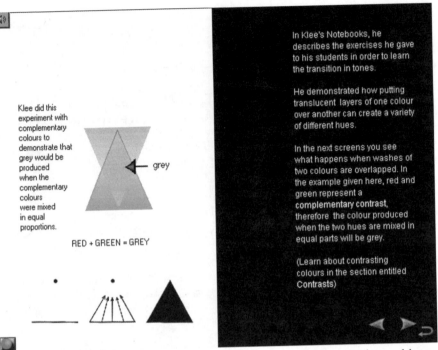

In Klee's Notebooks, he describes the exercises he gave to his students in order to learn the transition in tones.

He demonstrated how putting translucent layers of one colour over another can create a variety of different hues.

In the next screens you see what happens when washes of two colours are overlapped. In the example given here, red and green represent a complementary contrast, therefore the colour produced when the two hues are mixed in equal parts will be grey.

(Learn about contrasting colours in the section entitled Contrasts)

Klee did this experiment with complementary colours to demonstrate that grey would be produced when the complementary colours were mixed in equal proportions.

grey

RED + GREEN = GREY

Fig. 6. (A) Part of animation based on Klee's Notebooks, demonstrating superimposed layers of complementary colours.

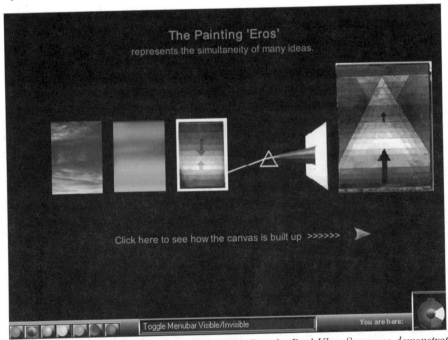

(B) Graphic diagram of composition of the painting Eros by Paul Klee. Sequence demonstrating links between the colours of sunset, the prism and Goethe's idea of the Primordial Phenomenon from his Theory of Colours.

symbols.[9] It would therefore be a logical step for a teacher to demonstrate the manifestation of ideas within the paintings themselves.

In the section 'Colour Theory – Klee', relevant chapters of Klee's *Notebooks*[10] were selected and explored through animation. Familiarity with these concepts enables the user to perceive echoes in the completed paintings. Given that the inter-referential possibilities are vast, it is therefore easy for teachers to select the relevant themes and follow them throughout the different subsections. Only those themes that were also relevant elsewhere in the presentation were selected, highlighting one or two of the most central points. This opens the possibility for the users – either teacher or pupil – to use their imaginations to draw up further conclusions. Thus, the focus here is on a distinguishing feature of Klee's theory of colour, his emphasis on the analogy between music and colour. Here, among other criteria, Klee's use of translucent washes to represent the different voices of harmonies in his *Canon of Colour Totality* is explained visually, as is the fact that the rhythm of tones and music were important to the flux within the painting.

The section 'Colour Theory – Klee' has close associations with the section on musical analogy, which includes sub-sections 'Parallels With Shape' and 'Musical And Visual Tone' as well as an interpretation of the painting *Ancient Sound/Harmony (Alter Klang*, 1925, Öffentliche Kunstsammlung, Basel).[11] In 'Parallels with Shape', for example, having taken Klee's *Notebooks* as a point of reference, the way that certain abstract forms can suggest noises or sounds is demonstrated. For example, a jagged shape suggests the sound of glass breaking, a spiral shape suggests an equivalent whirring sound. With this kind of on-screen participation the teacher can demonstrate, or the pupils themselves can experiment with, the activities linking sound and vision. The user therefore participates in these analogies by clicking on each one of a set of bold shapes on the screen to discover the equivalent noise. Also, in the introduction the user is invited to pass the cursor across Klee's painting *Tightrope Walker (Seiltänzer*, 1923, lithograph, Centre Georges Pompidou, Paris / Musée national d'art modern, Neuilly-sur-Seine) in order to hear different sounds which focus on the varying textures of line contained within the composition. The actual sounds that arise are my own interpretation but the basic idea is in keeping with the concepts from Klee's *Notebooks* (particularly 'The Thinking Eye') where he describes the idea of taking a line for a walk, as though the line has a temporal significance through the viewer's imagination, which calls up the physical experience of tracing along a line through a variety of abstract atmospheres.

The series of screens which follow provide the opportunity for the teacher or user to click buttons which break apart the composition of a polyphony painting to see the various layers of coloured washes and textures that are intended to be suggestive of the different voices in polyphonic music. Thus the pupils have the chance to be gradually introduced to interrelated concepts that extend the significance of colour within the composition.

Similarly, in 'Musical and Visual Tone', for example, the user has the opportunity

to play a tune on-screen (Fig. 3B) and discover the relevant visual tonal equivalent or numerical codification (Figs. 3A, 4A and B), in order to observe more closely these analogies between the senses of sound and colour or tonal recognition. The user has the chance to experiment with the abstract idea that the rising and falling of sequences of tones in music is similar to the gradations of tone or numerical patterns (compare Figs. 3B, 4A, 5A and B).

The learning process is altered because, rather than being purely chronological in development it is accumulative. Therefore you do not need a start, middle and end because you build a thematic and multi-dimensional understanding of the subject. Thus, through this kind of learning, although each section in the presentation is self-contained, it gains richness if viewed in relation to the points made elsewhere. For example, the experience of the section on 'Musical Analogies' is enhanced if viewed with relation to the following points, which are brought out in independent sections:

• 'Paul Klee's Colour Theory' as mentioned above, where the 'Canon of Colour Totality' is explored, along with the basis of spatial and temporal issues within the painting, such as flux and rhythm.

• Albert Munsell's codification of graded shapes as numbers and as related to music, which is considered in more detail through interactive animations in the sections, 'The Munsell System' and 'Codifying Colours'.

• The colour theorists Charles Blanc and Goethe had suggested music and colour were related harmonies, and that both media have the capacity to affect the senses directly; this is indicated in their respective sections.

Through the interactive introduction, therefore, my aim is to demonstrate some of the notions behind Klee's *Magic Square* compositions. The section culminates with an animated analysis of the painting *Alter Klang*. The animation demonstrates, by drawing together the disciplines of music and vision, what Klee might have meant by the different registers of voices within the painting. As the music of a Bach toccata plays the melody in higher notes, the lighter toned squares of the composition are accentuated, and where the darker harmonies of the bass grow into a crescendo of musical chords, within the animation the darker tones at the edges of the painting are built up in unison. The iridescent colours of the centre of the composition are therefore presented as a subtly vibrating mosaic of light colours set against the profound dark-brown harmonies at the edges of the composition.

Through this musical interpretation of the ideas contained in Paul Klee's *Notebooks*, especially *The Thinking Eye*, the painting is introduced as containing the kind of resonance that is also present in harmonies of music. This theme recurs in relation to the paintings of Rothko as seen in the 'America' section, when the same painting, *Alter Klang*, is set against the glowing canvases of Rothko, which

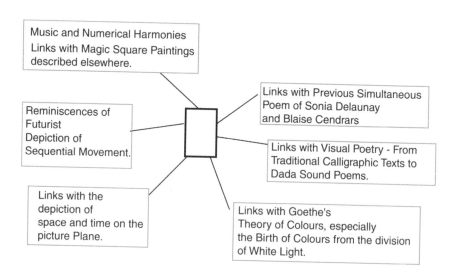

Fig. 7. Synthesis of many themes in one painting. (A) Original flow chart - Preparation of animated screen.

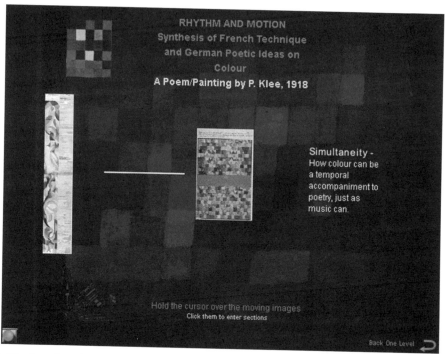

(B) The flow chart is animated on screen and acts as a menu for further information. Clicking the centre animates the screen, demonstrating that the poem/painting discusses verbally and visually the transition from day into night, echoing discussions of similar themes in other paintings.

are also said to appear to resonate with 'inner light' in a way similar to chords of music.

Example of the Co-relationship of Many Themes as Present in one Composition – 'Synthesis – Rhythm and Motion'

The section 'Synthesis – Rhythm and Motion' represents a point of consolidation and focus within the CD-ROM for the user to collect together the cross-section of ideas (Fig. 7). The aim here, is to recall the themes presented within one screen, through the analysis of one particular painting, and yet maintain awareness that there are many subtle differences between the manner that these themes are treated in the different eras of Western modernism. This is to reinforce the diversity of ideas at play in any one painting and encapsulates the cross-referential advantages of multimedia.

The section opens with a screen where the painting *Once Emerged from the Grey of Night* (*Einst in dem Grau der Nacht*, 1918, Paul Klee Stiftung, Kunstmuseum, Berne) is represented by an icon at the nucleus of an animated flow chart, where icons representing themes which recur in other sections, circulate around the nucleus and are consciously set up to act as subliminal references – like symbolic representations of the *leit-motifs* which are repeated throughout the presentation.

Placing the cursor on any one of these animated icons pauses the animation and clicking on the icon reveals a summary of the theme which is discussed in more detail elsewhere in the CD-ROM presentation, emphasising its relevance to this particular painting. On clicking the painting itself, situated in the centre of the screen, an animation displaying the text in German and English begins to play, with accompanying music of the period by Eric Satie, extracted from *Enfantines* of 1913. The inclusion of music is particularly effective in augmenting the sensation of unfolding time as the words of the poem follow the transition of colours from day to night.[12]

3. Problem Solving – Adaptations Necessary to Suit an Ever-Advancing Technology

Development Towards Web Publication

New technologies change so rapidly that it was felt important that the project should adapt accordingly. Throughout the planning of the CD-ROM, consideration of the hardware equipment available to the user audience was crucial, but in a fast-moving area of technology it is also necessary to use all the facilities available to the user of the future.

Early in the research, the possibility of linking the CD-ROM to websites had been

explored and this gradually became possible. A wealth of relevant websites can now be accessed directly from the presentation, which extends the scope of the project considerably. Similarly, several adjustments were made to make certain features compatible with the web. For example, some parts of the Macromedia Director presentation were adapted as online documents, therefore requiring the plugin for Shockwave. With the increased availability of broadband within educational and artistic institutions, such facilities will become increasingly common, therefore the most recent section on American Abstract Expressionism was fully developed for the web publication using a combination of HTML pages with inserted Macromedia Flash documents. The Flash documents can either be included in a Director presentation or independently launched on the web. To reduce loading times, 'streaming' techniques were adopted, which means the first part is played while the remainder is still loading.

Using Flash and Experimenting with the Wide Screen

In the HTML and Flash setup, the possibilities of navigating a wide screen were explored, enabling the user to scroll width-wise between subsections. Through this version the user may access the main information, and scroll along the screen to find reference to supplementary items, such as a list of noteworthy contemporary personalities, or information on exhibitions that were held during the period.

Another example of the use of the wide screen is in the section on Barnett Newman, where for example, alongside the main information it is possible to view reproductions of typical paintings of his early, middle and late periods which contain hotspots indicating information on the salient points of each style.

User activity was also developed further in this web-compatible version. For example, in the section on Rothko the user clicks on the paintings on the walls of a graphic representation of the Houston chapel in order to reach the subsections. Rothko's works, which use colour as metaphor and with relation to musical and linguistic analogies, can be set alongside those of Jackson Pollock, where colour is aligned with gestural and action painting.

Links with other sections, such as the previously mentioned 'Movement – Tracing the Artist' are reinforced and activities illustrate the similarities. For example, the user can pass the cursor across a blank canvas and leave colourful trails, similar to the manner in which Pollock let paint drip on his canvases.

The final era of the presentation represents another focus point, culminating in a comparative analysis of two paintings from different eras, *Eros* by Paul Klee, which has been analysed elsewhere in the CD-ROM, and *Horizon Light* by Barnett Newman (1949, Sheldon Memorial Art Gallery and Sculpture Garden, University of Nebraska-Lincoln). They would appear to represent a set of very similar issues,

but the method of production and scale of the resultant compositions of paintings pinpoint the change in the role of colour in the two different eras.

Here therefore, another way of organising many themes on one page is manifest, this time as a more conventional row of buttons where the themes are represented by the titles of the button links. The two paintings are compared and analysed with relation to the list of themes, which recall discussions from other areas of the CD-ROM. Thus the subtle differences between the use of colour in the different eras of Modernism are accentuated.

Conclusion: Towards a Network Society

The potential for the medium as an art-educational tool has been demonstrated through examples from the CD-ROM. Especially useful are the navigational possibilities for cross-referencing and comparative analysis which multimedia presentations permit, also the didactic capacity to include animations, sequences of slides and user activities.

The methodology of learning is also affected. The information is more accessible because verbal issues are discussed, as far as possible, within the visual language and, therefore, the use of text within the screens is kept to a minimum. Instead animation and visual means are employed to take advantage of the direct communication that colour can provide. Also, throughout the creation of the visual presentation, there was consciousness of the need to preserve the linear thread of each section, but the user would gain cumulative knowledge whilst passing from section to section as a coherent flow of an idea or theme exists, which recurs as a series of *leit-motifs* throughout the work.

Multimedia can be especially suited to art historical surveys because their flexibility enables either individual paintings or whole art historical epochs to be approached from both technical and historical angles within one study. In this case, the significance of synthesis, familiar to Modernist artists, is reinforced within the present-day capacities of multimedia. In addition the ideas themselves, which depend upon the use of various senses, are made more accessible, assimilated more rapidly, and have the capacity to be understood more profoundly through the interactive medium.

Thus a formula is created which is very easily extended towards a network society. In the light of new interest in learning objects, modules can be created with user activities which can be chosen and customised by teachers to create a greater general understanding of the languages involved in paintings of the Modernist period.

Notes

1 My definition of interactive here being, containing user choice and clickable activities.

2 Supervised internally by Dr. Fran Lloyd and externally by Professor Martin Kemp.

3 The home page of this bilingual site is at www.futuro.usp.br. The Virtual Library, in Portuguese is at www.bibvirt.futuro.usp (both active 15 November 2002).

4 The Blue Rider to which Delaunay and Klee were affiliated was founded by Franz Marc and Wassily Kandinsky in Munich in 1911.

5 A recent book by J. Golding, (2002), *Paths to the Absolute*, Thames and Hudson, discusses this with relation to various epochs of Modernist painting. With regard to Kandinsky's vision of an absolute art, John Harrison (2001), in *Synaesthesia, The Strangest Thing*, Oxford University Press, reflects whether the *Gesamtkunstwerk* might be a result of his synaesthesia, concluding: 'The evidence suggests that Kandinsky was seeking a synaesthetic dimension to his work, rather than his art being an expression of his synaesthesia.'

6 The simultaneous painting/poem *Prose of the Trans-Siberian Railway and Little Jehanne of France* by Sonia Delaunay and Blaise Cendrars is discussed with relation to Apollinaire's words that the work could be viewed as a whole or as a linear accompaniment '...in order to train the eye to read with one glance the whole of a poem, as an orchestra conductor reads with one glance the notes placed up and down on the bar, as one sees with a single glance the plastic elements printed on a poster.' The quote was originally from *Les Soirées de Paris* published on 15 June 1914, see: Cohen, A. A. (1975), *Sonia Delaunay*, New York: Harry N. Abrams, p. 35. See also Cendrars, B. (1992), *Complete Poems,* (trans. R. Padgett, intro. Bochner, J.), University of California Press, p. 98.

7 *The Rite of Spring* by Stravinsky was first performed in 1913, when its musical structure shocked the public. For general outline of music and painting at this time, see: Dennison, L. (1993), '1912', *Art of This Century*. The Guggenheim Museum and its Collection; Solomon R. Guggenheim Foundation, p. 109f. This essay discusses the many events which have influenced subsequent twentieth-century artistic expression.

8 Siegel, D. (1998), *Creating Killer Websites*, Hayden Books, (see also www.killersites.com, active 15 November 2002). Chapter two suggests the idea of an 'umbrella' metaphor that arouses curiosity for channelling, entering and continuing the navigation. It also creates a logical sign system for recognising and distinguishing navigational icons.

9 Such interpretations were prevalent within a wider context in the Modernist period, therefore they can easily serve as a basis for a general understanding of how abstract elements of the composition – especially, in this case, colour – were thought to convey meaning.

10 Klee, P. (1964), 'The Thinking Eye', *The Notebooks of Paul Klee*, Spiller, J. (ed.), London and New York, 2nd. ed., Vol. 1. Originally published as *Bildnerische Denken*.

11 *Klang* is the word also used by Kandinsky in many compositions which draw parallels between sound and colour as seen in his 'Concerning the Spiritual in Art'. For an analysis of music in Klee's work see Kagan, A. (1983), *Paul Klee: Art and Music*, New York: Ithaca. Also more recently Kudielka, R. (2002), 'Colour and I are one. The Journey to Tunisia and the Origin of the Square Paintings', *Paul Klee, The Nature of Creation*, exh. cat., Hayward Gallery, London.

12 For example, this painting *Once Emerged from the Grey of Night* (1918), represents one stage in Paul Klee's journey to synthesise many themes in one painting through the use of colour alone. Klee achieved this more fully through later paintings such as *Eros* (1923). Also the *Polyphony* paintings, discussed in the section 'Parallels With Shape' of the CD-ROM represent a more sophisticated manifestation of synthesis, since they do not resort to the use of text in order to create a linear flow from one colour to the next, but instead, rhythmical musical analogies take precedence. Semiotic analyses of the painting *Once Emerged from the Grey of Night* exist in two essays in the book, Crone, R. and Koerner, J. (1991), *Paul Klee. Legends of the Sign*, NY: Columbia University Press. The essay by Crone, R. '*Cosmic Fragments of Meaning: On the Syllables of Paul Klee*', p. 37, is especially relevant.

The Cathedral as a Virtual Encyclopaedia: Reconstructing the 'Texts' of Chartres Cathedral

Stephen Clancy

Imagine that you are an architectural historian five hundred years hence, who is interested in the meaning that a particular public building held for those who used its spaces and viewed its surfaces at the turn of the twenty-first century. You would certainly be interested in the attitudes and images these audiences brought to the experience – the thoughts, visual memories, and beliefs that acted as the lenses through which the physical environment was experienced. You would also realize that the building acted as an architectural umbrella for experiences that varied over time and space, and between different users and different occasions. At the very least you would have to concede that the building was not a static entity: its impact clearly varied with the experiences and attitudes of the individuals who moved through its spaces.

A static, fixed interpretation is precisely the sort of exercise that most students of medieval architecture are offered today. This is especially problematic with the Gothic cathedral, which is the focus of this project. Traditional methods of presentation and study – for example, the art-historical slide lecture – can only hope to summarise abstractly the dynamism of the Gothic cathedral. As Professor Robert Calkins of Cornell University has so aptly put it, the Gothic cathedral 'is an encyclopaedia in stone and glass, the *summa* of medieval architectural form.'[1] It functioned as a multi-faceted cultural 'text' that was both 'written' and 'read' by its varied users. The sculpture on its doorways, for example, embodied rich and seemingly contradictory concepts of judgment, compassion, chivalry and power. The figure of St. Theodore from the north transept portals was probably understood differently by those from different social classes, and one's reception of the sculpture might well have varied depending upon the nature of one's past experiences with the French knightly class. Even the spaces themselves encoded ideas about social hierarchy, with different classes of society being permitted different levels of access and freedom in the cathedral's interior spaces. While tourist groups wander freely through it now, a medieval worker in the vineyards was forbidden to set foot in the choir ambulatory of Chartres Cathedral during services,[2] and would have approached and experienced the building and its imagery in a vastly different fashion from that of the Dean of the cathedral's chapter.

Today we in our turn attempt to 'read' this architectural 'encyclopaedia' in order to

understand the religious beliefs, cultural values, and secular practices encoded within it. But our own cultural attitudes and educational practices get in the way. We view the cathedral and its environment as tourists, consumers or connoisseurs instead of reading their significance through the lens of medieval cultural attitudes: in essence, we experience the cathedral as twenty-first-century visitors to one of the 'great sights of the past,' instead of thirteenth-century participants in one of the dominant, contemporary social institutions. In addition, the slides and photographs we use to explain the cathedral treat the building merely as a series of static, two-dimensional visual compositions, devoid of spatial continuity, and divorced from the urban and social contexts that gave it meaning. Indeed, the static isolation of the slide has given rise to the side-by-side 'stylistic comparison' approach,[3] which treats the history of medieval architecture as an evolution in style, as if the buildings were oil paintings by Monet. The early Gothic façade of Chartres Cathedral, for example, is said to have 'evolved' into the High Gothic façade of Amiens, which, in turn, 'evolved' into the proto-Flamboyant façade of Reims.

Our modern, static images are also unable to evoke the original appearance of the walls and spaces of the cathedral and its urban environment, in large part because the cathedral's structure, imagery, furnishings, and surroundings have changed or vanished over time. The loss of the cathedral's medieval urban environment is particularly significant. To experience a cathedral after parking in an underground garage, traipsing through a Monoprix, and sipping an espresso at a café is quite a different thing from viewing it at the end of a week-long pilgrimage on foot, after travelling through fortified gatehouses, up shadowed streets filled with merchants' stalls, and past money-changers crowding the transept portals. The 'Virtually Reconstructed Chartres Cathedral' project was conceived as a way of using recent and rapid advancements in digital technologies and software as tools for beginning to bridge this gulf between the twenty-first and thirteenth centuries. It was also conceived as a way to substitute a dynamic, interactive, and spatially continuous experience of the cathedral for the static and passive experience that most classrooms provide. Chartres Cathedral serves as the vehicle for this project because it brings us closer to the thirteenth century than most other cathedrals. Much of its original stained glass, sculpture, and structure survive relatively intact; it still houses a number of its medieval liturgical objects and relics; the thirteenth-century street plan around the cathedral largely survives; and even a few late-medieval houses still stand along the access routes to the cathedral. The project was inspired, in part, by the Amiens Cathedral project, created by Stephen Murray and a team of multimedia designers at Columbia University. This website,[4] funded by the National Endowment for the Humanities, demonstrated the value of using digital technologies to make accessible a variety of contextual materials about a cathedral. It also pioneered the use of panoramas to recreate virtually a sense of the spaces within a cathedral.

Building upon these efforts, the Chartres Cathedral project proposes to use digital technologies to accomplish four goals: (1) to simulate digitally the twenty-first-century architectural spaces in and around the cathedral; (2) to provide a means of interacting with these twenty-first-century spaces, and the images and objects

within them; and (3) to simulate digitally the thirteenth-century architectural spaces; and (4) to create a sense of how they were experienced by their varied audiences in the later Middle Ages. Obviously a project such as this requires a considerable amount of human, institutional, and monetary support, and here I have been fortunate. Ithaca College supported the project with course release time, and also funded two trips to Chartres, so that I could shoot the images that form the basis for the panoramas. In addition, I have received support from two broader institutional grants, the first from the Keck Foundation, and the current grant from the Hewlett Foundation. The Keck grant provided software and some faculty training, and also the funds to construct a state-of-the-art digital classroom. Equipped with high-end Macintosh computers with cinemascope monitors, and three back-projection screens for both digital and analogue images, the facility has become the testing ground for many of the project's ideas. Finally, the Hewlett Foundation's grant to Ithaca College has funded release time, software training and student collaboration. Most importantly, throughout the entire project I have benefited enormously from the collaboration of Professor John Barr of Ithaca College's Math and Computer Science department, whose expertise in Macromedia Director has enabled the creation of prototypes of the finished project.

Before any aspect of the project could be implemented however, I needed to acquire the raw material for our work: the images in and around Chartres Cathedral that would form the basis for the panoramas and other views of the finished project. This required two trips to Chartres, the first using a traditional 35 mm camera for slides that were also scanned, and the second using a relatively high-resolution digital camera. Both trips required the use of a special tripod head, which held the camera in place for the panorama shots, and rotated the camera every twenty degrees, for a total of eighteen shots per panorama sequence.[5] The use of a 24 mm lens meant that the panoramas would cover as much vertical view as possible, without significant distortion.

Before each trip, I plotted the location of panoramas on a thirteenth-century street plan of Chartres, as well as on plans of the cathedral itself and its immediate environs. My goal was to construct at least two panorama pathways leading from former gateways through the city wall to the cathedral. Each pathway proceeds along medieval streets and through the wall that once separated the cathedral cloister from the rest of the town (Fig. 1). I have also panoramas of the exterior of the cathedral, and in front of each one of the three sets of portals. Finally, I created interior panoramas – the most difficult to shoot because of lighting conditions – to provide complete coverage of the cathedral's interior spaces. Many additional 'still shots' were taken of all of the important imagery outside and inside the building, including each ground-level stained-glass window, and all of the sculpture on the outside of the building. Finally, I manufactured a number of 'textures', which are such images as half-timber architecture, rough stone masonry, fortified walls and gatehouses, and even pollarded trees, both in Chartres and elsewhere, to serve as the material for transforming the panoramas into thirteenth-century versions. With eighteen images per panorama, 47 panoramas, and several panoramas that

Fig. 1. Street plan of thirteenth-century Chartres.

had to be taken two or three times, I have over 1,600 images of the cathedral and the town. *QuickTime VR Authoring Studio* software, which runs only on the Macintosh platform,[6] creates each panorama out of the original eighteen images, and also creates an underlying image file that can be manipulated in Adobe Photoshop.

The next phase of the project involves researching primary and secondary sources for evidence of the original appearance and spatial layout of the cathedral and its urban setting, and evidence of political, social, and economic transactions with a direct bearing upon how the cathedral might have been experienced in the thirteenth century. Some of this evidence is visual: black and white photographs survive of the Porte Guillaume gatehouse before it was demolished by the Germans on their way out of Chartres in 1944. Other research taps into the archaeological record. For example, the thirteenth-century choir screen, or *jubé*, no longer survives. It was replaced in the sixteenth century by the screen that currently separates the ambulatory from the altar area. The screen separating the choir from the nave has vanished completely, conveying a sense of openness and easy access that never existed during the Middle Ages. Based on fragments that have been recovered, and comparisons with other thirteenth-century choir screens, it is possible to reconstruct plausibly the appearance of Chartres' thirteenth-century *jubé*.[7] Finally, urban histories of Chartres and the surrounding region provide insight into the social practices and physical environments within the thirteenth-century town,[8] including evidence of the economic and political tensions between

Fig. 2. Twenty-first-century panorama of Chartres.

the cathedral's chapter and the Count of Chartres, which affected how the cathedral was used, and the kinds of images included in its stained glass.[9]

It is one thing, however, to acquire an intellectual sense of what something looked like in the thirteenth century and another to attempt to recreate these appearances digitally, especially when one is trained as an art historian rather than as a graphic designer! Using Adobe Photoshop, some student-workers and I have tackled the steep curve of learning how to revise existing panoramas to match what might have appeared in the thirteenth century. Photoshop provides a variety of ways of layering both subtle and large-scale adjustments and applying both pre-set and imported textures over existing images. Fig. 2, for example, is the image file that represents the twenty-first-century panorama just outside the Porte Guillaume, scaled to one-tenth its actual size. To transform it, the 1944 photo of the gatehouse was resized and reoriented, and placed in approximately the position it occupied in the late Middle Ages. Then textures were layered on top of this gatehouse, to give it the proper colour and appearance (Fig. 3).

Fig. 3. Gatehouse with texture layers.

Next, using existing sections of the medieval wall still partially standing elsewhere in Chartres, a new curtain wall with bastions was constructed. The process was laborious, because it required careful layering of textures at precise angles to match the viewer's perspective; the borrowing of certain elements, such as the hoarding, from other locations; and the creation of yet other elements, such as the crenellation of the bastion towers, from scratch (Fig. 4).

I also replaced the modern urban sprawl on the bank of the River Eure opposite the medieval town with flat farmland. A single half-timber building is added to evoke the isolated nature of architecture outside the medieval city walls. Finally, although they by no means appear as they will in the finished version, two soldiers, heraldic

Fig. 4. Created elements: crenellation on top of the bastion towers.

Fig. 5. Castle of the Count of Chartres with overlays.

banners, and roofs from the long-destroyed castle of the Count of Chartres are placed as overlays on the panorama (Fig. 5).

In the finished project, these elements will serve as focal points for virtual interactions, allowing students to experience some of the political and economic factors that influenced a pilgrim's understanding of Chartres and its cathedral. The result, while not, at this point, 'factual', nevertheless provides a plausible thirteenth-century view, and serves to dramatise the difference between this visual environment and the setting we experience seven centuries later.

The cathedral's interiors present similar challenges: although the structure remains largely intact, numerous additions and changes in practice have altered considerably the physical environment that would have enveloped a medieval pilgrim. Today chairs fill both transept arms and the nave. In the thirteenth century, there were seats only in the choir for the clergy, the chapter, and their invited guests.[10] The bulk of those attending mass at Chartres either stood on the cold stone floor, or rested against a few bales of hay strewn about. A student has partially completed the job of removing the modern chairs, which requires careful reconstruction of some of the pier bases. A greyed-out area reveals the location of the medieval choir screen, which would have blocked the view into the crossing area. At a point near the famous *Belle Verrière* stained-glass window along the choir ambulatory, a modern glowing glass sculpture and informational posters have been erected, competing with the light from the stained-glass windows. In addition, the sixteenth-century choir screen provides a flowery sculptural character completely at odds with the thirteenth-century screen. I have begun the process of transformation by eliminating the glass sculpture, and inserting the individual shots of stained-glass windows into their locations within the panorama, to simulate thirteenth-century lighting effects. A prototype of the thirteenth-century choir screen has replaced a section of the sixteenth-century version, dramatically

illustrating how the thirteenth-century visual environment within the ambulatory differed from what we see today.

The last of the concurrent project phases is the creation of interactive interfaces that will allow students to explore both the twenty-first and thirteenth-century versions of the panorama and related imagery. Using Macromedia Director, which can seamlessly integrate a variety of media, and provide a means for viewers to experience these media interactively, John Barr and I have begun the process of creating two different 'virtual pathways' through the cathedral and its urban setting. We have yet to concern ourselves with the final 'look and feel' of the design interface, and much of the textual material is only a preliminary draft. Both versions of the project will begin at the same location: approaching the town from the wheat fields outside of Chartres, gazing at the distant cathedral.

Fig. 6. The first pathway - the 'virtual discovery tour'.

The first pathway – the 'virtual discovery tour' – seeks to place students in Chartres as it currently exists (Fig. 6). A series of 'hotspots' will be created within each twenty-first-century panorama; these hotspots activate different buttons placed next to the panorama. These buttons, in turn, activate a set of images and a series of questions designed to focus students' attention on particular issues related to that part of the panorama. A hotspot by the remains of the Porte Guillaume, for example, will lead to a set of images and diagrams of gatehouses, and a series of questions that will prompt students to consider how the Porte Guillaume might have functioned in the thirteenth century. An 'inventory' keeps track of the number of hotspots visited by the student, and will not allow them to proceed to the next panorama until they have visited all of the hotspots. The hotspots are signalled only by a change in the cursor's shape; the goal is to force students to explore the entire panorama with their own eyes, and not to focus them

on only a few select images, as in the traditional classroom presentation. Additionally, an illustrated timeline will provide students with an historical context in which to place their experiences. A map will allow the student to keep track of where they have been, and to return to prior panoramas. Once a student has navigated all of the hotspots offered by one panorama, they can proceed to the next.

The second pathway, which sends students back to the thirteenth century, will take much longer to make, since it requires a full set of 'transformed' panoramas, which are very time-consuming to create. Once finished, however, this pathway will be characterised by a total immersion into a thirteenth-century visual environment. A student will enter the thirteenth-century experience through a door in the lower right-hand corner of the computer screen. When the door opens, students will find themselves confronting a panorama with computer-generated 'visual aids', such as buttons or arrows. The intent is to ensure that students explore and interact with the panorama as if they were actually standing in the location represented by the panorama, rather than experiencing the image through an interface outside the image. By exploring the panorama with their cursor, and interacting with the various hotspots that will eventually confront them, students will simulate the randomness of actual experience. The interactions themselves will force the students to confront the kinds of experiences that would have faced a pilgrim in the thirteenth century. For example, upon reaching the Porte Guillaume, a pilgrim would probably have been forced to deal with those guarding the entrance to the city, and would have had to pay an 'entrance tax' before being allowed to continue on their journey. Professor Barr and I are in the process of constructing a dialogue with one of the soldiers outside the gatehouse. This dialogue will require students to pay the fee out of their own 'virtual purse', and will confront students with the knowledge that the Count of Chartres, not the cathedral, controls access to the streets leading to the cathedral (Fig. 7). Similar interactions will be constructed for the other soldier, the heraldic banner, and the distant view of the Count's castle; all of these images are intended to spark mental images drawn from visual memories and evoke simulated culturally-determined beliefs in the mind of our 'virtual pilgrim'.

The project is, obviously, a work in progress; indeed, the time-consuming nature of the work has caused me to re-evaluate the project's goals. What has become evident is that the collaborative work itself, both with professionals in other disciplines – such as a computer scientist – and with students, is not simply a means to an end, but is itself one of the fundamental benefits of the project. Art history has always relied upon technology in its teaching and scholarship; in fact, the advent of slide projectors, and their side-by-side placement in the classroom, fundamentally shaped the way we present art history to students and to each other.[11] Yet many art historians are either reluctant to embrace the digital image, or instead simply use digital images as substitutes for slides. Collaboration with a professional who must, by the nature of his profession, embrace new digital technologies has forced me to confront the ways in which technology might be used not simply to replicate the existing structures of our discipline, but rather to reshape the very substance of what we teach, and the means by which students

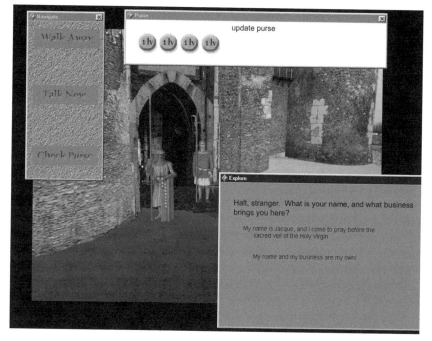

Fig. 7. The 'virtual pilgrim' experience.

access and interact with that substance. Additionally, the collaboration with students has provided them with valuable 'hands-on' learning experiences that integrate the study of architectural history with education in digital skills that will be very useful to them in the marketplace. Regrettably, art historians have traditionally shied away from considering this factor.

Obviously, the impact of this project upon how students learn architectural history cannot yet be judged. I have made preliminary attempts to shape interactions between my students and the twenty-first-century panoramas, centred on questions that require them to evaluate the experience as it unfolds. The sense of active participation and discovery within the classroom is palpable. At the very least, the substitution of panoramic images for static, two-dimensional images provides a sense of space and continuity, and allows students to explore a complete visual environment at their own pace, rather than being handed a limited and predetermined set of images. The addition of interactive hotspots opens the potential for a fully self-guided, exploration-driven, and hands-on educational experience. If, in the end, the project can provide a plausible simulation of the physical environments and social transactions a thirteenth-century traveller to Chartres might have experienced, and at the same time allow students to 'learn by doing' rather than 'learn by listening', I believe the effort behind the project will have been worthwhile.

Notes

1 Calkins, R. (1995), 'The Cathedral as Text', *Humanities*, November/December, p. 35.

2 See Erlande-Brandenburg, A. (1994), *The Cathedral: The Social and Architectural Dynamics of Construction*, (trans. M. Thom), Cambridge and New York: Cambridge University Press, pp. 269-277.

3 See generally Pointon, M. (1997), *History of Art. A Students' Handbook*, 4th ed., London and New York: Routledge, p. 42; Minor, V. H. (2001), *Art History's History*, 2nd ed., Upper Saddle River, NJ: Prentice-Hall, Inc., p. 25f.

4 The site is located at www.learn.columbia.edu/Mcahweb/index-frame.html (active 26 November 2001). For a book that treats Amiens cathedral fully within its social context, and deals also with the modern experience of the cathedral, see Murray, S. (1996), *Notre Dame, Cathedral of Amiens: The Power of Change in Gothic*, Cambridge and New York: Cambridge University Press.

5 For panoramic tripod heads, see www.kaidan.com/products/pano-prods.html (active 26 November 2001).

6 Editor's note: a number of similar products which run on other platforms are also available.

7 See generally Mallion, J. (1964), *Chartres: le jubé de la cathédrale*, Chartres, Société archéologique d'Eure-et-Loir.

8 See, e.g., Chédeville A. (1973), *Chartres et ses campagnes (XIe – XIIIe s.)*, Paris: Editions Klincksieck; Michel, M. (1984), *Développement des villes moyennes: Chartres, Dreux, Evreux*, Paris: Publications de la Sorbonne.

9 For a discussion of how stained-glass imagery at Chartres reflects the thirteenth-century social structures and political turmoil within the town, see Williams, J. W. (1993), *Bread, Wine, & Money: The Windows of the Trades at Chartres Cathedral*, Chicago and London: University of Chicago Press.

10 See Merlet, L., and de Lépinois, E., 'The Charter of 1221 Concerning the Rights of the Cantor over the Choir Stalls', *Cartulaire de Notre-Dame de Chartres 2*, pp. 95-96, (trans. and reprinted in Branner, R. (ed.)), (1969), *Chartres Cathedral*, New York and London: W. W. Norton & Co., pp. 97-98.

11 See generally Bailey, C., and Graham, M., 'Compare and Contrast: the impact of digital image technology on art history', *Digital Environments: Design, Heritage and Architecture. Proceedings of the Fifteenth Annual Conference of CHArt (Computers and the History of Art)*, University of Glasgow, 24-25 September 1999, available at www.chart.ac.uk/chart1999/papers/bailey-graham.html (active 26 November 2001).

With Camera to India, Iran and Afghanistan:
Access to Multimedia Sources of Explorer, Professor Dr Morgenstierne (1892-1975)

Wlodek Witek

Georg Morgenstierne (1892-1978) was Professor of Indo-Iranian languages at the University of Oslo, Norway. His bibliography lists 221 published books and articles. The National Library of Norway, Oslo and the Institute of East-European and Oriental Languages at the University of Oslo have joined to create a multimedia database containing source materials from Morgenstierne's study tours to isolated areas of Afghanistan, Pakistan, India and Iran. The archive of some 3500 items contains primarily photographs, though sound recordings, moving images and sketches are also included. Some of this material records the last known traces of an ancient Asian culture before it succumbed to Islam.

Only a handful of the University employees had access to the grey steel cabinet in the seminar room of the Indo-Iranian Library at the Oslo campus. Even fewer knew what the many, yellowed envelopes contained. Knut Kristiansen, lecturer in Hindi and Indian literature, kept a watchful eye on his old mentor's papers, the Morgenstierne archive. As he approached retirement in the 1990s his concern for the archive made him act. Something had to be done about the long-term preservation and access to the numerous photographs and other records from South Asia brought to the Institute by the respected linguist, Georg Valentin von Munthe af Morgenstierne (Fig. 1). The Institute of East European and Oriental Languages sought a partnership with Norway's major library, The University of Oslo Library (now The National Library of Norway) in order to find a way of preserving this important collection. A deal was struck that a database for the picture material would be created by a joint effort and the actual collection would become the responsibility of The National Library when the work was finished. During the process the condition of the archive was to be evaluated and necessary measures taken to ensure its physical preservation. It was believed that the Library had the means and expertise to cope with the tasks of both preservation and future access.

Fig. 1. Georg Morgenstierne at fieldwork in Afghanistan. (c) Georges Redard, Nijrau, 14 October 1962.

Geography and Politics

Although Georg Morgenstierne travelled extensively throughout South Asia, from Sri Lanka to Iran, by far the most notable were his visits to the inaccessible areas of the Hindukush Mountains. The high, snow-covered passes and dangerous roads have helped to keep a large mountain area isolated for centuries. Access to the valleys was controlled from the east by the ruler of Chitral, the Mehtar, while the notorious reputation of the mountain people, the Kafirs, as neighbouring Muslims called the unbelievers, did their best to scare off any intruders from any other side of Kafiristan. Kafiristan, or the Land of the Infidel, lay to the east of Kabul, north of Jalalabad, south of Uzbekistan and west of Chitral (Fig. 2). The area, known for its deposits of lapis lazuli, served as a buffer zone between Afghanistan and colonial India fearing attack from the Russian Empire in the north. Undoubtedly, Kafiristan posed a great threat to the stability of the region and thus, unwillingly, became a territory of the Great Game at the end of the nineteenth century. Better control of the northern border of India became a high priority for the Crown. As to the ruler of Kabul, he wanted to expand his influence as far east as possible and convert 'the wild tribes' who for so many centuries molested the neighbouring Muslims with numerous bloody attacks and looting.

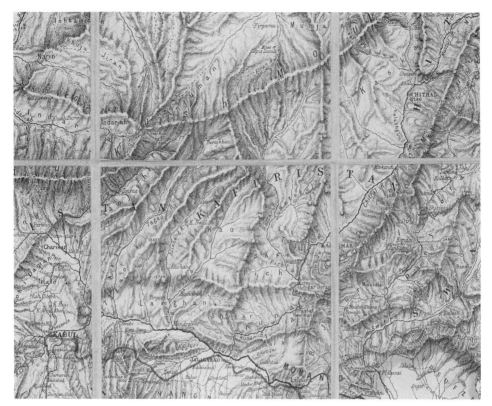

Fig. 2. Map showing the location of Kafiristan. Fragment of Stanford's large scale Map of Afghanistan, 1880.

History and Conflict

The year 1896 was to become fateful for the Kafir culture. It was then that the Durand Line was drawn to limit India's influence over the unexplored Kafiristan. The Line is still the border between Afghanistan and Pakistan, north of the Khyber Pass. Shortly after the Durand Line was drawn the Emir of Kabul, Abdur Rahman, successfully conducted a military campaign, sacking Kafiristan and imposing Islam onto the conquered tribes. Kafiristan was invaded several times and eventually stripped of its cultural identity. Altars were burned, priests murdered, boys kidnapped and conscripted to military school in Kabul. Only several hundred Kati Kafirs (the Red Kafirs of the Bashgal Valley) managed to flee across the border. The Mehtar of Chitral gave them conditional permission to settle in the neighbouring valleys of Rumbur, Bumboret and Urtsun, which were then inhabited by the Kalasha tribe (the Black Kafirs). Being so deeply uprooted, the Kati refugees willingly converted to Islam and by the mid 1930s all had given up their old beliefs (Fig. 3). Effectively, only the Kalash people who lived on the Chitral side of the border remained unconverted. All what used to be known as Kafiristan on the Afghan side of the border became the Land of Enlightenment, Nuristan.

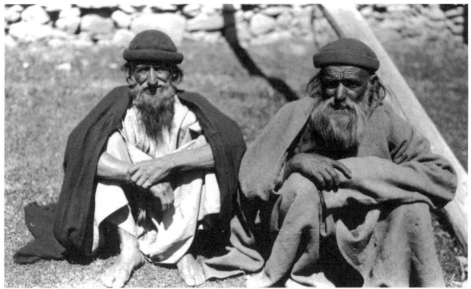

Fig. 3. The chief Bagashai and the chanting priest Kareik, the last of the Afghan Kati 'unbelievers' (Red Kafirs) and priests. By 1935, six years after this photograph was taken, both were dead.

Exploration

Georg Morgenstierne was clearly attracted by the mysterious stories of Rudyard Kipling, such as Kim. Like the Norwegian explorer Fridtjof Nansen, he was driven to search and discover what was yet unknown. His linguistic background was a good start, but it was his marriage to Agnes Konow that made his dream of becoming a discoverer come true. Agnes was brought up in India. She was a daughter of the Norwegian Indologist Sten Konow (1867-1948) who was instrumental in two monumental publications: *The Archaeological Survey of India* by John Marshall (1906-07) and *The Linguistic Survey of India* by George A. Grierson (1903-28). Morgenstierne's letters to his wife give us a valuable insight into what it was like to be on a linguistic mission to lands where few Europeans ever ventured.[1]

Nuristan's Unknown Languages

A brief political thaw in Afghanistan allowed Morgenstierne to obtain a permit and visit the country for the first time in 1924. He started his journey from Peshawar in an automobile with his hired Pathan assistant, Yasin Khan, as well as a Russian and an Italian. In those days the dangerous road from Peshawar, through Jalalabad to Kabul claimed many victims to crime. Even today the road still retains its bad reputation. The middle leg of the trip across the Kunar River continued on the back of an elephant, at times a more reliable means of transport. Once in Kabul, Morgenstierne set to work straight away. Despite a favourable political climate in Afghanistan, the linguist was still prohibited from leaving a closely-defined perimeter outside of Kabul. His faithful Yasin spotted the first Kafir-language

speakers in the bazaar and persuaded them to speak in their native tongues in front of the linguist. The Nuristani from the Kabul market-places were to provide a valuable first insight into the complex patchwork of the unknown languages of Nuristan.[2] Morgenstierne was to wait for over 25 years before he could return to Afghanistan and travel to Nuristan proper, which he did for the first time in 1949. His second linguistic expedition, however, started in 1929. Only Chitral was open to his linguistic research and strict orders were given not to cross the Afghanistan border. This trip and years of comparative studies that followed resulted in a proposed map of the distribution of the many surprisingly ancient languages in this area (Fig. 4).[3] Morgenstierne argued that the Nuristani (Kafir) family of languages that includes Kati, Prasun and Ashkun, was possibly formed even before the separation of the Iranian from the Indian language over 3000 years ago. Highly controversial at the time, this claim remains his most important discovery.

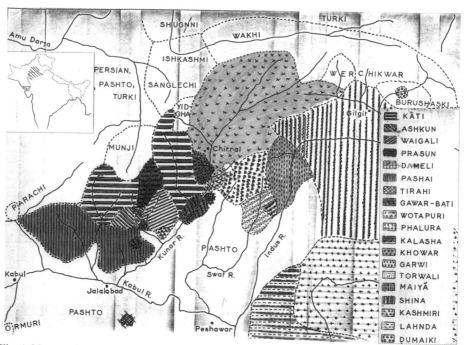

Fig. 4. Morgenstierne's map showing languages spoken in Nuristan and Chitral.

Ancient Languages and Religions

The ancient origin of the Kafir culture is an indication of the age of the indigenous peoples and their northern origin. The Kafir religion resembles the Vedic religion of the Aryan invaders of the Indian continent who destroyed the rural Harappa culture of the Indus Valley around 1500 BC. It is believed that the Kafirs could be descendants of the Aryan invaders who stayed in the Hindukush Mountains.

Tough Traveller

Throughout his career Morgenstierne did his fieldwork in the East on eight occasions, spanning a period of nearly 50 years of exploration. He climbed high mountain passes, visited feared tribes in the jungle of Assam, rode horses, donkeys and elephants, moved by car, steamer and airplane, but when it really mattered just set off on foot like a typical mountain-loving Norwegian. On one of his last trips to Afghanistan, when he was 76, he was deeply hurt for having been refused on grounds of his advanced age 'permission to enter Nuristan'.

Records of a Disappearing World

Morgenstierne's trip of 1929 was by far his most exceptional. We are today in possession of a surprising wealth of information few researchers know about. Scarcely any other serious traveller before him brought so much diverse documentation, not to mention moving images and audio, of the Kafir culture. Nearly all the material symbols of the Kafir culture were destroyed by the invading Afghan army in 1896. A few trophies, rare wooden sculptures, found their way to Kabul Museum and a total of eighteen were recorded there in the 1960s.[3]

After the Soviet invasion of 1978, the civil war of the 1990s and recent Taliban rule, the museum is a ruin with only a fraction of the mainly Islamic collection surviving. The wooden Kafir art was probably used as firewood.

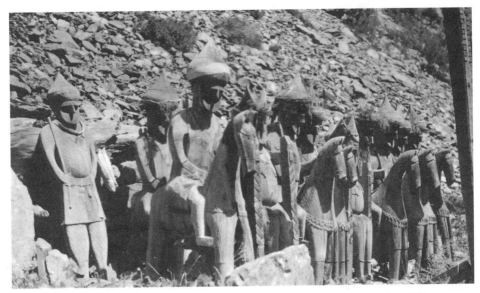

Fig. 5. Effigies of Kafir ancestors by a burial ground, Brumotul, Pakistan, 19 May 1929.

Ancestral Effigies

The expressive wooden figures were meaningful in a social context. They symbolized social status of prominent individuals or represented deities. A mounted horseman seated on a twin-headed animal represented the highest status achievable for a tribe member and was earned either by throwing lavish feasts to at least one village or by becoming a successful assassin. The ancestral figures (gandau) were raised after death and placed in a group on the outer perimeter of the burial ground, where coffins were left unburied (Fig. 5).

The skill of woodcarving lay exclusively in the hands of the bari, the lowest ranking artisan caste of the Kafirs. Smaller effigies (kundik) would be raised in the fields where a symbolic figure of a standing, seated or mounted ancestor could watch over and protect the crops of his descendants from the high position, perched in a simple construction of stone and timber. Although Kafir culture was strongly dominated by men, women also could gain high social rank and be depicted seated or standing after death.

Altars and Shrines

The few altars and shrines remaining today can only be found in the Kalash valleys of Birir, Bumboret and Rumbur in Chitral. Neither Muslims nor women can approach the sites for fear of 'polluting' them. Altars in the name of the highest God Imra (or Mara) used to be found by every village where sacrifices were made. The altars to Imra consisted of a stone boulder and a flagstone placed as a tabletop where purifying fires of juniper would burn during frequent sacrificial ceremonies. The stone altars are all gone, even in Chitral. A shrine to another powerful God has been preserved in the oak forest where the God, Sajigor has his place of worship. Mahandeo-dur (altar to the God Mahandeo) can be also found in secluded sites. These sites display similar layout features. They are simple timber and stone constructions with carved vertical and horizontal patterned wood, crowned with protruding long-necked horse heads. The area in front would normally include a number of raised, richly carved poles, each set up in memory of the generous members of the tribe who sponsored feasts. There would also be a hearth for a sacrificial fire in the middle. During important religious occasions a priest would sacrifice bread, cheese, fruit, butter or animal blood. In earlier times bulls were offered. Today, since other domestic animals are no longer plentiful, only precious goats are offered to the Gods.

Household Utensils and Furniture

Practically any wooden surface was an excuse for carved decoration. These were always produced by the bari caste of craftsmen. The emblems and symbols cut into bowls and doors had to reflect the social status of the owner for whom they were made.

Fig. 6. The Kegal chairs discovered and photographed in 1949 (detail of a larger photograph), Kegal, Afghanistan, 8 Nov 1949.

Chairs in Kafiristan were not as common as in other parts of the world. In fact, the use of chairs outdoors was strictly restricted to only those who earned that right. Women could also attain such a high status, but indoors no such rule had to be observed. Kafir chairs were made in several styles according to area and/or tribe (see Klimburg). Especially the 'horn-chairs' from the Waigal Valley attracted the attention of researchers as soon as they had been discovered by Morgiensterne in the village of Kegal in 1949. The figures of mating couples carved on the back of one of the two chairs are extremely rare (Jones 1970). Such figures seem to also form the high 'horns' of the furniture (Fig. 6).

Striking, horned head-dresses crowning the heads of Kati women were commonplace in the Bashgal Valley up till 1896. There are several descriptions and photographs of them (see Jones). The earliest descriptions are from the late 1800s and the most detailed record with an illustration was provided by George Robertson in his book *The Kafirs of Hindu-Kush* (Robertson 1896). These peculiarly shaped woollen caps had four long horns made of human hair. When a four-horned goat was born in the herd, it was considered a good omen, a sign of favour from the gods. This is what the neighbouring Kalash tribe believed. Today, there are two known specimens in public collections, one in the Oslo Ethnographic Museum and the other in the Victoria and Albert Museum in London (Fig. 7). A

Fig. 7. Horned head-dress worn solely by Kati women in pre-Islamic times. Ethnographic Museum, Oslo.

variant of a horned head-dress (with short horns and no human hair) is in the Graziozi Collection at the Anthropological Museum in Florence and another one in the Moesgaard Museum in Aarhus, Denmark.

A Database of Photographs, Moving Images and Audio Recordings

The bulk of Morgenstierne's travel records are in the form of some 3000 photographs. The earliest are contact prints from postcard-size negative film from the 1920s; the latest, from the 1970s, are made on colour slide film and Polaroid direct positive colour paper. On one of his early trips to India and Chitral in 1929, he took a movie camera and audio recording equipment with him. The movie

archive consists of over 100 short clips from a total of twenty minutes of silent movie. There are about 40 speech recordings of about 30 seconds each.

All the images, even some dubious landscapes and poor quality images are included in the database. It was possible to identify all images, even those with little detail. It was felt that this 'all-inclusive' approach was the only acceptable way to approach a serious researcher's archive of images from little known parts of the world. This way the original material was spared unnecessary handling and could be kept in conditions suitable for photographic archives. All images were put in transparent, archival polyester sleeves, chronologically sorted and stored in archival quality boxes in an air-conditioned room at the Norway National Library, Oslo. Access to the database is unrestricted and free of charge.

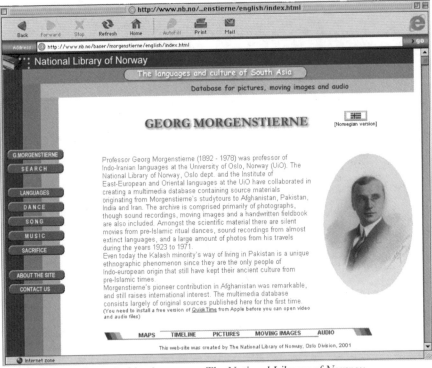

Fig. 8. The Morgenstierne Archive homepage. The National Library of Norway.
http://www.nb.no/baser/morgenstierne/english/

The Norway National Library Website (www.nb.no/baser/morgenstierne)

Certain interesting cultural aspects of the collection may seem to be too well hidden in the large number of items represented. Some researchers may also be inexperienced in the use of search tools provided by databases. It was therefore thought useful, if not entirely necessary, to create a few web pages in order to emphasize some records (Fig. 8). Subjects of dance, music and sacrifice were

therefore singled out and some recent video, audio and photographs were added. These are accessed from the homepage. The website and all records are written both in Norwegian and English.

The Project Team

The project team was formed in 1997 as a small group of four specialists, but ended in 2000 with just two. None of the group worked full-time. Knut Kristiansen's role needs to be emphasized as he was crucial to the success of content identification. He knew G. Morgenstierne well, was familiar with some of the Indian languages and had visited Chitral in recent years. His tragic and unexplained death in 1999 was a hard blow, yet his professional contribution has already been so fruitful that the rest of the project was not jeopardised.

The prototype software, MediaFinder was used for the database input. It was designed by Kolbjørn Aambø for the Oslo University Library in 1990, when it was created for the Nansen picture network-archive, the library's first intranet picture database that gave access to a sizable collection of photographs.

Elisabeth Eide, Head of the National Library collections, made the Morgenstierne project possible. She was also responsible for proofreading and the budget.

Technical Notes

Scanning of the images was spread over time and was carried out in-house by hired personnel. Digitisation of the moving images was carried out externally in 1998 from only one existing film copy; the original nitrate film being lost. All the audio recordings, also copies of wax cylinders, now lost, were copied from 78 rpm copy records to digital audio and converted to QuickTime files. The audio and moving image editing was done by the project team who were familiar with the content of the whole collection. The Library phased out its Apple Mac equipment by 1999 and the core material is now editable through direct access to the Trip database, now available to World Wide Web users.

References

Morgenstierne, G. (1992), *På sprogjakt; Hindukush: Dagboksnotater fra Chitral 1929*, Oslo: Eva M. Lorentzen.

Morgenstierne, G. (1926), *Report on a linguistic mission to Afghanistan, Oslo, Instituttet for sammenlignende kulturforskning*, Serie C; 1: 2.

Edelberg, L. (1960), 'Statues de bois rapportées du Kafiristan a Kabul après la conquête de cette province par l'Èmir Abdul Rahman en 1895/96', *Artes Asiatiques*, 2: 4.

Bibliography

Edelberg, L. and Jones, S. (1979), *Nuristan*, Graz.

Grierson, G. A. (1903-1928), *Linguistic Survey of India*. Calcutta.

Jones, S. (1970), *The Waigal Horn Chair*, Reprinted from Man, 5: 2, London.

Jettmar, K. (1986), *The Religions of the Hindukush*, Vol. 1, *The Religion of the Kafirs*, London.

Klimburg, M. (1983), 'The Monumental Art of Status among the Kafirs of Hindu-Kush', Snoy P., (ed.), *Ethnologie und Geschichte. Festschrift für Karl Jettmar*, Weisbaden.

Klimburg, M. (1987), 'Notes on the Architecture of Nuristan', *Archiv für Völkerkunde*, Vol. 41, Wien.

Klimburg, M. (1976), 'Male-Female Polarity Symbolism in Kafir Art and Religion', *New Aspects in the Study of the Kafirs of the Hindu-Kush. East and West, N. S.*, Vol. 26, Rome.

Lothian, A. C. (1955) (ed.), *A Handbook for Travellers in India, Pakistan, Burma and Ceylon*, London: Murray.

Morgenstierne, G. (1932), *Report on a Linguistic Mission to North Western India*, Oslo.

Morgenstierne, G. (1951), 'Some Kati myths and hymns', *Acta Orientalia*, Vol. 22.

Morgenstierne, G. (1973), *Irano-Dardica*, Wiesbaden: Ludwig Reichert Verlag.

Robertson, G. S. (1896), *The Kafirs of the Hindu-Kush*, London.

Schomberg, R. C. F. (1938), *Kafirs and Glaciers*, London.

Towards a Yet Newer Laocoon. Or, What We Can Learn from Interacting with Computer Games

Michael Hammel

Working with interactive art makes it clear that something has happened to one of the basic rules of an art museum: the rule that keeps artworks being art or, at least, artefacts (Fig. 1). At first, this rule might look as if it has been imposed to ensure long life for the artefacts, but it also prevents the artworks from becoming things: the rule keeps them being art (or, at least, artefacts).

Fig. 1. 'Please Do Not Touch! We are the relics of your culture'. The Museum of the Palace of Jodhpur, India. © Photo: Michael Hammel, 1998.

The User

If you do not touch an interactive artwork, you will have no experience of it, but if you do, you might get more than you bargained for. By touching the artwork you fall through a magic trap-door and become a tactile user connected to the interface and mentally absorbed in the depths of the visual environment. As a user you become involved. You might even become addicted and begin to live in your own world isolated from other people.

Fig. 2. The User and the Critic. © Michael Hammel, 2001.

The Critic

The story goes that the great modernist critic, Clement Greenberg, had a rather special ritual when looking at a new artwork. He would stand in a darkened room with his eyes closed, turning his back to assistants hanging a picture on the wall and adjusting the light. When ready, Greenberg would turn around, saying 'hit me!'

His many enemies might have made up the story in order to ridicule him. What Greenberg was looking for was the flash of instantaneous visual experience: the naked, unspoiled sensation. He sought to highlight the painting's painterly effects at the cost of its narrative which he believed should be banned in painting. But what the flash also did was to prevent a story from evolving around the painting and engaging Greenberg. Since the painting came as an expected surprise, he did not move physically closer to it and remained fully detached. He thus avoided the even greater danger that the painting might attract his attention in which case he would

no longer be uninterested or detached as demanded of a Kantian aesthete. Interactive art puts an end to the supposed detachment, and emphasizes the reception of the work. The myth, however, is hard to kill. This is why I decided to turn to computer games, because computer games are not art. Computer games are dangerous!

The usual concern voiced about computer games is that young people spend too much time in front of the monitor shooting anything that moves, or playing secret agents in cyberspace. They get used to surreal environments and illogical behaviour. They should, instead, play hide-and-seek in the park outside, in the real reality, but they find coping with this reality difficult.

There is, arguably, a lot to learn from playing games. This is not, of course, a new insight into sociologically-oriented studies, where notable scholars such as Johan Huizinga, Victor Turner and Erving Goffman studied the different modes of play and social interaction within culture as a means of learning the rules that govern society. You learn to handle the game actions, solve the puzzles and survive. Hence you learn to live by the rules of the game. You are the player, embedded in the game and responsible for the action – at least for your protagonist's actions and for not getting killed or thrown out of the game.

Games such as *Doom* and *Myst* engage the player in the visual display through sound and visual effects, but mainly by employing the 'famed' first person camera view, i.e. central perspective. 'Cinematic' games, also known as third person or 3D games, such as *Tomb Raider* that brought Lara Croft to fame, employ changing viewpoints, a method which appeals to the more 'cinematic' players. The sexy curves of Lara Croft may appeal to the male eye, but you do not have time to sit back and enjoy them whilst you are playing. Boiling down the experience of playing computer games to one central aspect, such as the addiction to the game, you may ask what makes people play the same game over and over again. The reasons lie not in the attractive looks of the protagonist, but in the prospect of mastering the tasks in the game: the constant problem solving; how to get through; how to do what; and how to be better; becoming eventually a master of the game. This is the most important aspect for the player, but it is just one part of the story.

'Interactmen'

The sound in computer games is generally described as 'blearing'. It is meant to focus the player's attention on the game by drowning the outside. But it also contains more subtle effects, such as warning the player of opponents outside his field of vision, by indicating their position with sounds. A 'fix-sound' can be used to give the player a sense of direction by changing level and direction according to the protagonist's position within the game world. The sound represents a bond between the player and the character. Special artefacts may make a jingling sound when you get closer to them or to confirm an action.

As far as the graphics of the computer game are concerned, you will notice that some artefacts are highlighted or display an aureole when you move 'your hand' (the cursor) towards them. This effect makes some artefacts special and others, which do not get highlighted, less important. Other minor changes occur in the graphics in reaction to your cursor/hand. I call these minor but detectable changes in the appearance of objects (you will also find them in 'mouse-over' events on the web) 'interactmen': the smallest unit of interactive language. They could also be called interactive widgets. They can be considered as micro narratives or signs that announce a possibly greater narrative triggered by your reactions to the received impulse while you follow the path it promises.

Other impulses may be received through the joystick. You can, for example, 'feel' through the vibration of the joystick when your protagonist is exposed to a beating. This gives you the impression that the game involves not only the characters on the screen, but also yourself. When playing games, I can feel how this sensation prompts me to 'give back'.

Experience of Interaction

Playing computer games is synonymous with experiencing the present moment and this is conveyed through constant action and responses. There are three different modes of interaction while playing games:

1. Reaction: where your action is minimal (for example, the web);

2. Interaction: where you take part in some of the action (for example, *Doom*)

and;

3. Symbioaction: where you cannot differentiate between your own work and that of the machine, as in virtual reality science fiction (NB multi-player gives the same illusion).

If and when you interact, you interact with the whole of the work and the navigation is part of the content. This is different from the traditional conceptualization of user interface design. The stories that you tell others about your experience of the game world are also important. When you give your account of the game and compare your experience with those of the others, you get a better knowledge of the game. These narratives can only be understood in the context of the situation in which the interaction takes place.

Having described some of the main issues in the design of computer games, I will now look at an interactive artwork.

Fig. 3. Boxiganga: Smiles in Motion, *2000. Exhibited in the 'Kropsmaskinen', Museet for Samtidskunst, Roskilde. Photo © Kjell Yngve Petersen.*

Smiles in Motion

Smiles in Motion is a work made in 2000 by the Danish artists Kjell Yngve Petersen and Karin Sørensen, both members of the group Boxiganga (Fig. 3).

The work consists of two chairs connected through a computer. In order to experience this work you need a partner or assistant. You sit in a surprisingly comfortable chair, wearing a 'helmet'. The helmet contains a small monitor, video camera and a microphone. The monitor takes up the whole of your field of vision and displays the image of your partner's lips. All you see are huge, moving lips.

When you start to speak you see your lips on the screen. When your partner speaks your chair starts vibrating and you see the image of your partner's moving lips. Then you speak again; the louder you speak the more your partner's chair vibrates. Your partner tries to outdo your voice by talking even louder. This way the vibration fluctuates back and forth in an escalating pattern. No word comes through to your ear. All you hear is a deep, growling sound coming from the bottom of the chairs

and causing vibrations. The sound is transformed into vibrations that you feel with your body.

As one participant takes the lead over the other, the image of the lips on the monitor changes accordingly. It flickers back and forth between the image of your mouth and that of your companion. When the image of your lips disappears this gives you incentive to speak on, but the increasing vibration urges you to change the polarity again. This is similar to handling a joystick in computer games: it drives you subconsciously towards constant action.

I tried the chairs with different people and the experience was different every time. An artist told me that the best experience of the interaction he had was with an intimate friend, when they had experienced intimacy in a whole new, sensual and fascinating way.

During a public display of the chairs different people tried the experience. One of them was a woman whom I did not know. She did not like it at all. When her chair started to vibrate she jumped out and could not be persuaded to give it another try. The connotations of the vibration may be obtrusive and almost shocking to the unprepared user. She was an art critic on assignment from a Danish daily. Her review of the exhibition was not too good. She liked the web-based works best.

This case shows that in order to explore an interactive artwork you have to accept the challenge and get to know the work; find inspiration in the feelings it generates and create the stories around your experience.

The Name of the Game

I find many similarities between such artworks as *Smiles in Motion* and computer games. They are:

• Based on the user's cooperation with the creator's idea;
• Dynamic – what you do is (mostly) rewarded;
• Physical experiences, calling for your tactile reception;
• Multi-sensorial;
• Tasks;
• Challenges to the user, or may take over the user;
• The user must follow the rules laid down by the creator;
• The user creates a meta-narrative – a wit path in the confines of the work;
• The user must spend time familiarizing himself with the work before he can express any opinion about the work; by then he is already involved and this involvement is part of the game.

Both the artwork and the game are concerned with 'the what' and 'the how': how the path is created, how you – as the user – experience the participation, what you do, what makes you do it, and who controls the situation.

In Danish and German there are two different words to describe your experience of doing something (*Erfahrung*) and your personal experience while performing the task (*Erlebnis*). Generally, *Erfahrung* keeps you from damage and *Erlebnis* is the enjoyment or excitement you feel when exposed to the risk in an active situation. The female art critic went through the experience with the chair but was unable to enjoy this interactive artwork, while others may have been more open to the experience. Contrary to the traditional arts, the player's experience is strictly personal and generally cannot be verified. It depends on the actual viewing and interacting with the artwork. So, goodbye Mr Detached Critic and hello Mr Absorbed User!

But what Happened to the Way we Look at Art?

The traditional hermeneutic position is that the viewer decodes the hidden narrative in the artwork. In order to do so, the viewer should have some circumstantial knowledge of the artwork; its meaning may be immanent and waiting for the viewer to find the key to the story.

The reader's response is an opposite and extreme post-structuralist position, where the work is an empty sign and the viewer composes his story of the artwork through the actual viewing; the meaning rests solely in the viewer's mind.

A third position, much ignored by art critics and art historians, is also possible. This position puts the viewer's experience in the context of the artwork. When you work your path through the maze of an artwork (on the web) you might be the only one to choose that path. Your experience will be unique and based on your personal choices and interests. So the position of the Kantian aesthete is no longer valid: you cause the work and co-produce it with the artist(s); and when artificial intelligence is involved, the artwork becomes autonomous.

'Here's Looking at you, Kid'

My suggestion, therefore, is that you include yourself and the circumstances for the viewing situation in your description of the artwork. Tell the story of 'the how' and 'the what' of your encounter. As the artwork becomes increasingly complex – and might become artificially intelligent – there will be no truth beyond your description. It is important that you are 'in the story'. This has, rather successfully, been made one of the main methods of ethnography and social anthropology, and seems to be the only way to discuss artworks that are explored through physical and quasi-social interactions.

When you travel to exotic countries with strange customs and obscure rituals, you cannot exclude yourself from the story. It is you, and your curiosity, that is the driving force of the encounter. This must be considered as the methodological foundation for the study of interactive art. From there on you can go where the

action is and participate and bring knowledge of your interaction to the understanding of the artwork.

Visual Narratives

What we are looking at in interactive artwork is the evolving visual narrative that includes the user's actions. This results in a new and unique personal narrative created by the co-operation between the user and the creator of the artwork. Thus, the artwork becomes co-created by the user and the artist. We should also look at the structure and the role which the user is supposed to play in order to get an idea of the creator's aims. The artwork consists after all, of rules laid out by the artist for the player/user to follow. If the user/player fails to obey the rules he is thrown out of the game.

I hope I have made clear that with interactive artwork we must look at how the work tells its story by demanding a specific action from the users; this demand is embedded in the story created by the player in order to bring meaning to the action. The newer Laocoon opposes Greenberg's purism of the narrative or poetry and is, therefore, closer to Lessing's vision of the different arts seen as 'good neighbours'. I stress the importance of looking at the way viewers and players are included in the narrative of the artwork, as well as the narratives created in the minds of the players and users by interacting with the artwork.

In conclusion, we are all users, subjects in the world led by our interests. Even when we want to be professional, we create a story. In interactive art this narrative becomes more important and more evident than ever before. By looking at the narratives you look at the ideology of the interaction with a particular artwork. Every story includes a predefined user – yourself.

Further Reading

Fried, M. (1967), 'Art and Objecthood', *Artforum*, 5:10 (June) pp.12-23.

Greenberg, C. (1940), 'Towards a Newer Laocoon', *The Partisan Review*, 7:4, pp. 296-310.

Lessing, G. E. [1766], 'Laokoon. Oder, über die Grenzen der Malerei und der Poesie', *Lessings Werke*, 3, Weimar: Volksverlag (1959), Engl. edn. *The Laocoon, and other Prose Writings of Lessing,* (n.d.). Transl. and ed. by W. B. Ronnfeldt, Walter Scott.

Goffman, E. (1967), *Interaction Ritual,* New York.

Huizinga, J. [1938], *Homo Ludens. A Study of the Play-Element in Culture.* Transl. by R. F. Hull (1944), Routledge & Kegan Paul.

Turner, V. (1982), *From Ritual to Theatre: The Human seriousness of Play*, New York, NY, PAJ Publications.

Digital Arts On (the) Line

Dew Harrison and Suzette Worden

This paper concerns the ongoing research undertaken in the field of Digital Art at the Digital Media Research Centre, University of the West of England, Bristol (www.media.uwe.ac.uk/). It remains specific to the working partnership developed over the past three years with the Watershed Media Centre (www.watershed.co.uk) where action research has informed working practice, consequently determining further research. This symbiotic relationship is particularly fruitful in view of the climate of our current technocratic culture where media centres can be understood as the new art galleries for Digital Art in that they are becoming the main centres for the production, distribution and showcasing of this new art form. The paper discusses the significance of three projects and their outcomes evidencing the rapid changes occurring in this evolving and dynamic field of study and gives an in-depth account of a fourth project, the online exhibition entitled Net_Working, on show at www.dshed.net/networking. It has opened the way for further research into the curation and practice of Digital Art.

Project 1: Electric December

The Watershed's Electric December is a digital advent calendar now in its third year of production. The project objectives are to:

- Promote the diverse cultures of today's Bristol;

- Raise the profile of New Media creatives in Bristol;

- Raise public awareness of the web as a creative medium;

- Develop audiences for web-based creative product;

- Raise awareness of the web across the full spectrum of creative communities;

- Create networks to share and develop New Media skills.

For the 2001 calendar the contributors were asked to interpret life in the city at a particular hour of the clock with the idea of gradually assembling a picture of city life over the twenty-four days of the event, from 1.00 a.m. on 1 December to midnight on 24 December.

Fig. 1. The Electric December electronic advent calendar, December 2001.

This electronic advent calendar presents a collation of work indicating the range of digital activity undertaken in the South West region of the United Kingdom, mostly Bristol, which houses a plethora of digital creatives including Aardman Animations[1], BBC Wild[2], bolexbrothers[3] and nameless-uk[4]. Each day throughout December reveals a digital 'chocolate' in the form of an animation, video, graphic, game, poem and/or sound piece from a different media company, arts organisation, community group or individual. All the 24 calendar boxes are available in still-image form as e-mail Christmas cards before the complete multimedia boxes are due to opened. Electric December is now well-known as a Bristol showcase of British talent and this year is supported and sponsored by *The Guardian*.

The main premise of Electric December is that of fun and experimentation, it provides a creative outlet for those working on commercial projects and offers an international platform to local groups and schools. The Watershed provides technical advice and support to those who may not have the necessary computer skills and particularly encourages members of the local community who would not normally engage with new media, to take part in this project. This year has advanced those principles of encouragement and support by focusing on the establishment of a new working method where Dick Penny, the Watershed Director, has persuaded the professional commercial ventures to work with local groups to produce joint calendar boxes, an example of this is box number sixteen where Aardman Animations have worked alongside Withywood Community School. This has had exciting results for the community where a small local state

secondary school has not only created an accomplished piece of work with a leading animation company but is exhibiting it across the globe.

The University of the West of England's contribution is a calendar box for 13 December and is a video record of a live-streamed event, which took place on that day. We had Andy Sheppard, the jazz saxophonist, playing at the Watershed to a background of three screens connected to three Apple computers, which were managed by three of our MA in Digital Media students. The result was a dynamic synthesis of sound and vision with swirling abstract shapes and aural forms. The event was live-streamed between 7.00-8.30 p.m. and 9.00-10.30 p.m. and proved to be a well-attended public performance with a full audience. Those who could not buy tickets for the event itself could view the show on the large screen coming live into the Digital Café in the Watershed building, or on their own computers in their own homes. The Sheppard performance was a popular event for a number of reasons. First, he is a musician of international renown and status and was playing for Electric December, which now involves a good proportion of the local community, and so has high profile locally. Second, the calendar has been promoted by a national newspaper and has become an item of interest on a national scale now presenting an international artist playing on the global stage of the Internet to an international audience. This event was a prime example of the creative use of the new media communication channels now open to us all.

Project 2: Expansionslot

The Faculty of Art, Media and Design has developed a good working relationship with the Watershed Media Centre where research into new media is involved. Both are central investors in the creation, analysis and evaluation of a fast-changing art form. Interactive multimedia is taught as part of the Time-Based Media Degree at UWE. The production of interactive multimedia requires continual user feedback if fully functional and accessible pieces of work are to be created. Watershed provided their newly established Digital Café as a 'lab' for the third year undergraduates for this purpose. They continued to build their work in this public arena every Sunday for six weeks until the end of their course culminating in a two-week exhibition Expansionslot at the Digital Café in June 2000 (see: www.expansionslot.org). Throughout this studio time the students had acquired a public. Their work could be changed according to the user feedback they were given. Their audience felt that they had a direct influence on the creation of the work produced and this interest encouraged and empowered the students to complete. The results were most rewarding.

Project 3: Clark Digital Bursary

The idea of the Watershed as a glass laboratory for the production of new media work was strengthened but not initiated by Expansionslot. The Digital Media Research Centre has been closely involved with the development of the year long

MongrelSoft™ Linker 1.2

Invisible Geographies

| Info | Overview | Download | Activities | Help | Background |

Fig. 2. Graham Harwood/Mongrel's - 'Invisible Geographies' work for the Clark's Bursary, October 1999.

Clark/DA2 Digital Bursary (www.watershed.co.uk/bursary/partners.html) for the creative development and production of new work in digital media since its inception in 1997, and has observed and documented the process feeding the analysis and research outcomes back to the Watershed for implementation. The Bursary was formed with the aim of providing the opportunity for creative development in the production of new work in digital media. It is open nationally but proposed projects should have relevance to the South West UK region and be socially resonant. The bursary is now entering its fourth year and is currently in the selection process for three smaller projects which are to be undertaken throughout 2002-2003. A full report can be read at www.media.uwe.ac.uk/dml_frameset1.html

It has become evident over the research span of the bursary to date that the emphasis for the creation and support of digital art has shifted from the production of outcomes and artefacts to that of research and development. The aim of the bursary is to further the artists' own practice, perhaps expanding into new media for the first time, and it is now understood that this may result in an event, or series of events, instead of the creation of an art object. The Digital Café is a platform for these artists to engage the interest of the public and show their work in progress, they are also encouraged to run workshops and seminars to expand interest and

help their new audience to 'read' digital art while promoting and enriching their own work. The Watershed now provides both a 'lab culture' of technical support[5] and, through the Digital Café, audience/user feedback in the creative process. Thus it continues to develop its production and screening facilities to offer the artist dynamic user feedback and the audience the chance to witness and contribute to the creative process.

Project 4: Net_Working (www.dshed.net/networking): Online Exhibition and Curation

Through the AHRB (Art and Humanities Research Board) funded 'Digital Art Curation and Practice' research project the Research Fellow curated the Exchange Online exhibition, 27 October – 3 November 2000, to accompany the Exchange 2000 conference facilitating research in art, media and design at the Watershed Media Centre, 2-3 November 2000.[6] This virtual gallery of online work was the first large screening of online digital art work held at the Digital Café. It constituted an exhibition of twelve websites selected from eighteen international submissions, a response to a 'call' for art work put out across the World Wide Web and e-mailed to appropriate lists. There was the required selection panel of suitably qualified referees and a set of five selection criteria from which work was graded from 1 to 5, the final choices were substantial but small enough to be archived on one CD-ROM; all the work could be viewed in one, long sitting equivalent to an afternoon

Fig. 3. Home page for the Online Exhibition, November 2000.

spent viewing an exhibition in a conventional art gallery, and the single front screen of a dozen URL choices did not tax the viewer too severely (www.media.uwe.ac.uk/exchange2000/exhibition/).

One year later the process was repeated in order to curate the online exhibition – Net_Working – again at the Watershed's Digital Café but this time to accompany the CHArt 2000 conference held at the British Academy, with surprising results!

Within a week of putting out the 'call' for work on 25 September across the Web there were over 150 submissions and by the deadline of 12 November there were well over 300. There are four possible reasons for this escalation in submissions of web works for an online exhibition:

1. Further research within the year between exhibitions had targeted the main websites where artists browse looking for 'calls';[7]

2. The announcement was timely, late September, post the summer break when people are eager to begin work again;

3. The exhibition title and theme were phrased well-enough to engage interest;

4. There has been a surge of net activity by artists within the last year.

A combination of all of the above is most likely although the greater weight must lie in the latter two. It is evident that there has been an acceleration of artists using new media within their practice and the Internet can now support most elements of new media e.g. video, animation, sound, text, image manipulation, communication and Artificial Life forms. Engaging interest without being over deterministic is difficult, the theme needed to be open, flexible, slightly ambiguous and intriguing enough to catch a diversity of practice. The final call for work was as follows:

* * Net_Working * *

Online but non-linear meshed and inter-linked net works for the Net. Collaborated clusters of single entities, caught in the Web where medium is content.

Trawling for content with Net works which are:

> collaborative, co-operative, interlinked, conversational,

> human, supportive, interdependent, organic, inclusive,

> expansive, joining, connecting, uniting, enriching...

The work submitted covered a vast range of Internet art from all over the world. The URLs flooded in from Latvia and Estonia to Argentina and California, they

Fig. 4. Net_Working Narrative page.

covered documentary and web narratives to sound-led sites and hacktivism. The issues involved with exhibiting an online exhibition on this scale have led to further research concerning the curation, production and exhibition of online art. The sheer numbers of the Net_Working submissions indicated that Internet can now be understood as a living archive of digital art where the curation is the creation of a search engine hunting for an artist's name, title of work or content-led keyword. Virtual online exhibitions then become databases where the curator decides on the search mechanisms and methods of access (www.dshed.net/networking).

Problems Encountered

The wealth of submitted work changed the curation methods applied previously for smaller online exhibitions such as the Exchange 2000 Online Exhibition. These methods had been adapted from curation in the traditional terrestrial galleries where a panel of 'experts' would apply a set of selection criteria to the submitted works. For example, the selection criteria for the Exchange 2000 show were:

Fig. 5. Tiia Johannson's contribution from Estonia - her work is worthy but is little known outside a small circle of fellow artists.

- Visual aesthetic;

- Depth of content;

- Level of engagement;

- Originality;

- Extent of furthering research/practice;

- Ease of access and functionality.

For an exhibition on the scale of over 300 works any selection criteria would have had to narrow down the choices to the point of negating perfectly good pieces of work in different forms, whereas an open submission based on the theme would sustain the diversity of new media practice now apparent on the Internet. Having made a decision in favour of open submissions, the exhibition organisers[8] then faced the challenge of how the exhibition was to be viewed. How do you present 300 pieces of work on one monitor screen? Few net-artists are well-known in the art world, with the possible exceptions of JODI, Mongrel, Craighead and Atkinson and a handful of others. They are not so 'personality' driven as artists using more traditional media, preferring instead the anonymity of the Web and the temporary, ephemeral status of work on the net. (Although this is beginning to change as web art gains more of a foothold in the art scene). Therefore searching by name would not be sufficient.

We approached the problem by investigating the nature of online art and defining anticipated user needs, concluding that work on the Web is often intended to be short-lived and not realised as a piece to be permanently on show in a gallery or collection, where time on a server may be limited. Dynamic, generative work is difficult, often impossible, to archive as it only ever exists in its live state and interactive work requires a viewer to interact with, in order for it to be experienced.

Fig. 6. Stanza, an internationally known artist, contributed his amorphoscapes. He works with generative sounds and visuals often triggered by the viewer's use of the mouse. He chose 'other' as his category.

These computer works are present while the machine is turned on and has the required downloads and plugins and can only be accessed if the URLs are well promoted in the first place, otherwise they fail to be seen. From previous events it was evident that our exhibition viewer would be interested in the type of work, whether documentary or animation etc., where it originated from, which country and culture and who created it, whether is was by an individual or an organisation, they would also like some indication into what a piece is about, its content, narrative and context.

The exhibition team of five organisers then took 60 sites each and proceeded to explore the options for accessing numerous Internet sites from the interface of a single screen, considering the above points. The team was to check each site for functionality, speed and ease of access, viewing time and pace of engagement. They also took note of the content and form of the work on show. These observations would both assist the interface design for the exhibition and feed further research into the challenge of online curating.

They agreed that providing the viewer with many methods of accessing the work presented was preferable to offering only one and the exhibition can now be accessed through several choices, such as category; image; content; artist's name; title of piece and country of origin. Collating this very specific information meant opening a dialogue with 150 artists in order to obtain the following within the time limit of one week: title of work; name of artist/s involved; country of origin; 200 word statement; descriptive sentence and a 100 pixel square 72 dpi jpg image. The artists were also asked to declare a category for their work. It was necessary here to explain that this was clearly for reasons of navigation and not for 'labelling' purposes. Where argument was expected, we offered support: artists engaged with the Internet as an exhibition platform understand well the difficulties of interface and access. The artists were offered a list of possible categories to select from and

of course were able to extend this to more aptly 'catch' their work: text/poetry; game; web narrative; documentary; film/video; sound; hacktivism; gallery; other. Further categories have been added: portfolio; organisation; log/journal and multi-user domains. Many chose the 'other' category, which may require further definition and discussion.

The time span of one week in which to build the site was (predictably) unrealistic and artists continued to submit information. During the ten-day large screening of the exhibition at the Digital Café work was constantly put online as the support material came in. E-mail was the fast, direct communication channel between artists, the curation team, and interested parties, the dialogue begun in this format was extended to a live chat arena on the Web. This event was to exist between 7.00 – 9.00 p.m. on 26 November 2001, in effect the public forum continued throughout that night, allowing for different time-zones and the obvious need for artists to communicate about their evolving form of practice. The archive from this will feed further research into online curation.

Other events organised to enable artists to contribute to the discussion concerning practice in new media were:

• An opening event of presentations and discussion on 20 November 2001 to which there was a good turnout of the local artists involved in Net_Working. This was well attended by the public and again was archived for future research;

• A live link-up between delegates from the 4th International Conference on Modern Technology and Processes in Art, Media and Design held in Bangkok and a contingent of Net_Working artists at the Watershed. 28 November 2001, 10.00 - 11.30 a.m. (Bristol)/4.00 – 5.30 p.m. (Bangkok).

These two events together with the opening evening and the presentation of this paper at the CHArt annual conference brought the ten day exhibition much attention and it is envisaged that further focus on Net_Working will be given through a series of smaller exhibitions relating to the separate categories identified here. It is crucial that all the submitted work is seen and appreciated as a significant array of the range and diversity of digital art practice, and if this is achieved, it will be inevitable that this exhibition will be understood as a curated database of the living, dynamic archive that is the Internet. It is hoped that Net_Working will provide researchers with a fruitful case study for further research into both curation and practice in the field of digital art and new media.

Notes

1 www.aardman.com/ (active 27 November 2001).

2 www.bbcwild.com (active 27 November 2001).

3 www.bolexbrothers.com (active 27 November 2001).

4 www.nameless-uk.com (active 27 November 2001).

5 The working method of 'lab' culture is now evident in many media centres and organisations where technicians work with artists to produce new work. However, the most fruitful combination is where the technicians are artists in their own right and act as collaborators or co-authors rather than dispassionate programmers. Centres of good practice which can be given as examples here are PVA Org in Dorset and Hull Time-Based Arts: www.pva.org.uk, www.timebase.org (both active 27 November 2001).

6 www.media.uwe.ac.uk/exchange2000/exhibition (active 27 November 2001).

7 The 'call' went out to media centres, artist organisations, networks and individuals. The most lucrative places reaching the most artists are: Rhizome.org which has an international following, Turbulence which covers USA and Canada and Rezone which serves Eastern Europe. However all those contacted have mailing lists and websites with a global audience.

8 A team of five consisting of two UWE researchers, the Watershed events organiser, a new media artist and a Digital Café technician.

Bringing Pictorial Space to Life: Computer Techniques for the Analysis of Paintings[1]

Antonio Criminisi, Martin Kemp and Andrew Zisserman

1. Introduction

In the twentieth century, art and science were generally perceived as very diverse disciplines, with very few points of contact between them. Although there are signs that the schism is less sharp than it was, we are a long way from the situation that prevailed in the Italian Renaissance, when the distinction between those who practised what we call art and science was not sharply drawn.

The work in this paper – building upon that by Kemp[2] – aspires to show how scientific analysis and the study of art can interact and be mutually beneficial in achieving their goals. Novel and powerful computer techniques may help art historians to answer questions about geometry, depth and structure in Renaissance paintings. The focus of this paper is to show how computer graphics and computer vision can help give new kinds of answers to these and other questions about the spatial structure of paintings.

All the paintings that will be taken into consideration in this work share a great sense of perspective. Indeed, a perspectival structure of some elaboration is necessary if the proposed method is to yield meaningful results.

Filippo Brunelleschi's mid-fifteenth-century invention of linear perspective was quickly adopted by contemporaries such as Masaccio, Donatello, Piero della Francesca, Domenico Veneziano and Paolo Uccello as the best technique to convey the illusion of a three-dimensional scene on a flat surface such as a panel or a wall. Later, in the seventeenth and eighteenth centuries mathematicians such as Desargues, Pascal, Taylor and Monge who were interested in linear perspective, laid the foundations of modern *projective geometry*.[3] Projective geometry can be regarded as a powerful tool for modelling the rules of linear perspective in a metrical or algebraic framework.

Over the past ten years projective geometry has become the basis of many of the most powerful computer vision algorithms for three-dimensional reconstruction from multiple views.[4] In particular, the work on single-view metrology[5] provides tools and techniques to compute geometrically accurate three-dimensional models

from *single* perspective images. These single-view techniques are applicable to all perspectival images (such as photographs) and are extensively applied, in this paper, to paintings that adhere to the canonical rules of linear perspective in order to create a systematic illusion of space behind the picture plane.

This paper, rather than just showing three-dimensional reconstructions designed on the basis of data extracted from paintings, presents novel and general methods that may be applied *directly* to any perspective image for a thorough analysis of its geometry.

We should constantly bear in mind that a painting is a creation that relies upon the artist's and spectator's imagination to construct a new or artificial world, one in which the manipulation of orthodox perspective may be advantageous. Therefore, any purely geometric analysis must be carried out in a sensitive manner. Before any geometric reconstruction is applied it is necessary to ascertain the level of geometric accuracy within the painting and, by implication, the desire of its maker for perspectival precision.

This paper presents some simple techniques for assessing the consistency of painted geometry. This is done by using powerful techniques to analyse the location of vanishing points and vanishing lines, by checking the symmetry of arches and other curved structures and by analysing the rate of diminution of receding patterns (e.g. tiled floors and arched vaults).

If a painting conforms to the rules of linear perspective then it behaves, geometrically, as a perspective image and it can be treated as analogous to a straightforward photograph of an actual subject. Vision algorithms can then be applied to: generate new views of the painted scenes; analyse shapes and proportions of objects in the scene; complete partially occluded objects; reconstruct missing regions of patterns; perform a complete 3D reconstruction and an analysis of the possible ambiguities in reconstruction.

1.1. Alternative Methods in History of Art

The method advocated here should be set in the context of previous techniques for the analysis of perspective in paintings. There are now three main alternatives that exhibit different sets of advantages and disadvantages.

Hand-made

The longest standing method has been to draw lines on the surface of paintings, or, rather, on the surfaces of reproductions of paintings (for obvious reasons). The linear analyses may be conducted either directly on a reproduction, or by using transparent overlays, and the results may be shown either superimposed on a reproduction or as separate diagrams. Kemp[6] amongst others adopted this latter

form of presentation. The analysis of a painting should preferably be performed on as large a reproduction as is available, ideally life-size (though this is rarely possible). The advantages of the hand-drawn analyses are:

• The technique is congruent with that used by most artists, who typically constructed their illusions of space through preparatory work involving straight edge and linear measures (sometimes also using dividers and compasses);

• In the initial stage of analysis, the hand-drawn lines can work flexibly for experimental exploration of our intuitions about the structure of the depicted space.

The disadvantages are:

• It is all too common to find thick lines drawn on small reproductions of big paintings, with resultant imprecision;

• It is easy to make errors, as when drawing a line through the point of intersection of two other lines, in which the extension of the resulting line will deviate progressively in response to the error in exact placement at the vertex of the intersecting lines.

• Constructing diagrams for complex illusions is a lengthy process.

Traditional Computer Aided Design

More recently, data obtained from the analysis of paintings has been used to obtain a computer aided design (CAD) reconstruction of the depicted space, using standard programs.[7]

The advantages of the CAD reconstructions are:

• They depict spatial features with precision according to the classic rules of linear perspective;

• Using techniques for rendering, they produce pictorial effects of light, shade, colour and (to a degree) texture akin to those in the original image;

• They can be used to produce animated fly-throughs and externalised views of the reconstructed spaces that can be vivid aids to understanding.

The disadvantages are:

• They require data to be extracted in advance from the painting, often in an artificially 'tidied-up' manner, in order to work with the program;

• They acquire a separate existence from the original images and may assume an aura of precision and conviction that is attractive but spurious.

The Present Method

The method advocated here still belongs to the wide spectrum of CAD applications, but unlike traditional techniques, works directly from the surface of the painting, and does not, for the purpose of analysis, add any arbitrary data not embedded in the image itself.

The advantages are:

• Alternative starting assumptions about the space in the image can be explored with ease and compared;

• All the alternatives can be parametised in a rigorous, mathematical fashion;

• The internal consistencies and inconsistencies of the spatial representation are laid bare, using information available directly from the image itself and involving no re-drawing;

• The textures and colours of the original image are retained;

• Re-projection can scrutinise errors and allow for their correction;

• Degrees of inaccuracy can be estimated systematically across the surface of images;

• Fly-throughs and externalised views of the space can be produced with ease;

• Regions occluded by objects closer to the viewer can be systematically reconstructed.

The disadvantages are:

• The power of the analysis may be excessive for the quality of the information that the artist entered into the original painting;

• It is applicable with profit only to those paintings that were constructed with sustained attention to perspectival rules;

• The quality of resolution is dependent upon the quality of the source image.

Some of the disadvantages of the present method may apply also to the previous two methods.

The technique described in this paper could be seen as a more flexible computer-assisted analytical tool which, unlike other CAD applications, allows the user to analyse the geometrical information contained in the painting in a more rigorous way by exploring all the possible reconstruction alternatives systematically, avoiding implicit assumptions typical of the use of traditional geometric templates.

It seems that the third method is generally superior for the analysis of complex perspectival images, and point to the first three advantages as empirically decisive in relation to the other two methods.

Correlating the Results with Historical Knowledge

The results obtained by these or other possible methods all need to be correlated by the historian with three other main bodies of evidence:

1. The *archaeology* of the painting; that is to say the physical evidence embedded in the work which reveals the constructional methods employed. These include incised lines (such as are apparent in Masaccio's *Trinity*), underdrawings detectable with such techniques as infrared reflectography, and any *pentimenti* (changes of mind) visible in the surface of the painting;

2. Evidence from drawings by the artist and comparable artists about the methods they employed to construct perspectival spaces;

3. The techniques for spatial construction available at the time the paintings were made, as recorded in published and unpublished treatises and diagrams.

The remaining sections of the paper are organised as follows: section two describes some techniques to assess the accuracy of a painting's linear perspective. Section three presents algorithms to analyse patterns and shapes of objects in paintings. Finally, section four presents complete three-dimensional reconstructions of paintings, analyses the dependency of the reconstructed geometry upon the assumptions made and explores the possible reconstruction ambiguities. Throughout the paper the analytical work of art historians is shown side by side with the results originated by applying our efficient and rigorous vision techniques to paintings.

2. Assessing the Accuracy of a Painting's Linear Perspective

As stated in the introduction, injudicious application of reconstruction techniques to paintings may lead to disastrous results. Our first task is to assess how well a painting adheres to the rules of linear perspective; in other words, how accurately its geometry represents that of a three-dimensional scene. This section presents some simple techniques used to perform this task.

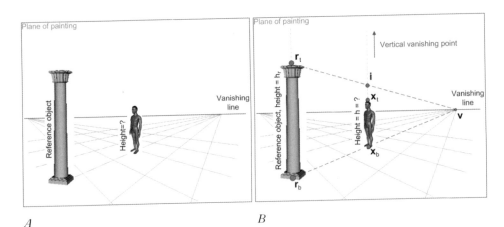

A B

Fig. 1. Measuring heights in paintings.
(A) We wish to compute the height of the human figure relative to the height of the column. The vanishing line of the image is supposed to have been computed.
(B) The ratio between the height of the man and that of the column is given by

$$\frac{h}{h_r} = \frac{d(x_t, x_b)}{d(i, x_b)}$$

2.1. Consistency of Vanishing Points

Under perspective projection (e.g. taking a photograph with a camera) lines parallel to each other in a real scene (e.g. the edges of a table, the tiles of a floor, or the edges of windows on a building façade) are imaged as converging lines on the image plane. The intersection point is called *vanishing point*. This holds for *any* set of lines as long as they are parallel to each other in the scene.

Therefore, the first technique for assessing the accuracy of a painting's geometry is that of analysing how well parallel lines converge into their vanishing point.

2.2. The Rate of Receding Regular Patterns

Assessing the consistency of the location of vanishing points or vanishing lines may not be sufficient to decide whether a painting obeys the rules of linear perspective. For example, in a drawing or painting of a regular pattern, such as a tiled floor, the edges of the tiles may consistently intersect in a single vanishing point, but the rate of diminution of the tiles' areas may be incorrect.[8]

A more interesting way of assessing the accuracy of the geometry of a painting is by comparing heights of objects, as described in the following section.

2.3. Comparing Heights

Even in perspectively-constructed images the artist might vary the height of

figures according to the status of those represented. Depictions of The Virgin and Child for example, were sometimes accorded a larger scale relative to persons of lesser status, in a way that is not immediately apparent to the unaided eye. The heights of donors, when depicted in paintings such as altarpieces, were particularly subject to variation in relation to the holy figures in the same or adjacent spaces. Therefore, comparing the heights of people in a painting can prove interesting in order to ascertain their consistency with the perspective rules and to attempt to establish whether any disproportion is an intentional response to hierarchies of status.

The schematic in Fig. 1 is used to explain how the heights of people can be computed *directly* from perspective images. In Fig. 1a we wish to compute the height of the man with respect to the height of the column. The vanishing line of the horizon has been computed. The line joining the base of the column (point r_b) with the base of the man (point x_b) intersects the vanishing line in the point v. The line joining the top of the column (point r_t) with the point v intersects the vertical through the man (dashed line) in the point i.

This construction has projected the chosen reference height onto the vertical through the man. In fact, the two lines $<r_b,v>$ and $<r_t,v>$ are images of parallel lines in space and the points i and r_t are at the same height from the ground, in space.

Finally, the ratio between the height of the man and the reference height is simply computed as a ratio between measurable image quantities.

$$\frac{h}{h_r} = \frac{d(x_t, x_b)}{d(i, x_b)}$$

In the case of photographs of real objects the reference height h_r may be known or can be measured *in situ* and therefore, the height of the people in the photo can be computed in absolute terms. When, as in the case of most paintings, the reference height is not known, we can only compute the ratio h/h_r; i.e. we compute the height of people relative to a chosen unitary reference height.

Notice that in this case we have assumed the vanishing point for the vertical direction to be at infinity (all the verticals are parallel to each other in the image) and a horizontal vanishing line of the ground-plane. This is a simplified version of our general, algebraic algorithm that can deal with finite vertical vanishing point and a ground-plane vanishing line in any orientation.[9]

Examples of the application of such a technique are presented in the following section.

Relative Heights in the **Flagellation**

Piero della Francesca's *Flagellation* (Fig. 2a), is one of the most studied Italian Renaissance paintings. It is a masterpiece of perspective technique. The obsessive correctness of its geometry makes it one of the most mathematically rewarding paintings for detailed analysis. In the past, art historians have dissected the painting with different laborious techniques, most of them manual[10] with the aim of understanding more about the artist's perspectival constructions.

The metrology algorithm described above has been applied in Fig. 2b to compute the heights of the people in the painting. Owing to the lack of an absolute reference, the heights have been computed relative to a chosen unit reference, i.e. the height of Christ. Therefore, height measurements are expressed as percentage variations from the height of Christ. At first glance it is not easy to say whether the figures in the background are consistent with the ones in the foreground, but our computer technique has given us the answer: despite small variations the measurements are all quite close to each other, thus confirming the extreme accuracy and care in details no less than in the overall space for which Piero della Francesca has become famed.[11]

3. Analysis of Patterns and Shapes

Art historians are often interested in analysing details such as a complex tile pattern, the shape of an arch or the plan of a vault. The manual techniques they use aim to invert the geometrical process that the artist employed to construct the

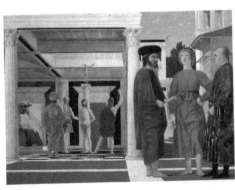 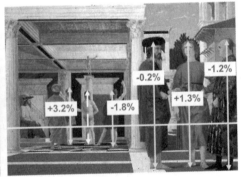

A *B*

Fig. 2. Comparing heights of people in a Renaissance painting.
(A) The original painting: Flagellation (c. 1453), 58.4 x 81.5 cm, by Piero della Francesca (1416-92), Galleria Nazionale delle Marche, Urbino. Courtesy of Ministero per i Beni e le Attività Culturali.
(B) The heights of people in the foreground and in the background has been measured relative to the height of Christ. They are expressed in percentage difference.

A

B

Fig. 3. Rectifying planar structures in photographs.
(A) A photograph of Keble College in Oxford, UK, with four selected points superimposed. The selected points are used to compute the homography between the scene plane and the image plane. (B) The automatically rectified image. The wall appears to be viewed from a frontal position. See text for details.

geometry of that pattern. Computer techniques can help achieve this 'geometric inversion' in a faster, more efficient and comprehensive way.

This section deals primarily with the generation of new views of planar patterns. This can be achieved by using plane-to-plane homographies. A plane-to-plane homography is a bijective projective transformation, mapping pairs of points between planes.[12] If the homography between a plane in the scene and the plane of the image (the retina or the canvas) is known, then the image of the planar surface can be rectified into a front-on view.

The world-to-image homography can be computed simply by knowing the relative position of four (at least) points on the scene plane and their corresponding positions in the image. Fig. 3 shows an example. Fig. 3a is a photograph of a flat wall of a building. The four corners of the window at the bottom left corner of the image have been selected and the homography between the plane of the wall and that of the photograph has been computed. The computed homography maps the selected four image points to a rectangle with the same aspect ration as that of the physical window. Thanks to the homography the original image has been warped via software into the rectified image shown in Fig. 3b. Thus, a new view of the wall has been generated as if it were seen from a frontal position.

Notice that no knowledge of camera pose or internal parameters (e.g. focal length, type of lens) was necessary. Furthermore, the quality of the rectification depends on the accuracy in selecting the four basis points. In the example in Fig. 3 those were selected by intersecting pairs of straight Canny edges[14] thus achieving subpixel localisation accuracy. The same rectification of slanted planar structures can be performed in perspective paintings as shown in the following section.

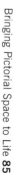

A

B

C

Fig. 4. Analysing a floor pattern, by hand and by computer

(A) An image of the floor pattern cropped from Fig. 2a.
(B) Manual rectification of the pattern achieved by Kemp.[13]
(C) Automatic rectification by computer. The rectified image has been obtained by applying our rectification algorithm to the image of the painting directly. The vertical streaks are the projectively distorted legs.

3.1. Rectifying the Floor of the *Flagellation*

Piero della Francesca's *Flagellation* (Fig. 2a) shows, on the left side, an interesting black and white floor pattern viewed at a grazing angle. Kemp[15] has manually analysed the shape of the pattern and demonstrated that it follows the 'square-root-of-two' rule. Fig. 4b shows the manually rectified image of the floor pattern patiently achieved by Kemp on the basis of a full-sized reproduction. The rectified pattern seems to be observed from above rather than at a grazing angle as in the original painting.

Fig. 4c shows the rectification achieved by applying a homography transformation as described above. In this case the four vertices of the black and white pattern have been selected as the base points for the computation of the homography. We have imposed those to be arranged as a perfect square. Notice the similarity between the computer-rectified and manually-rectified pattern. (Fig. 4c and Fig. 4b, respectively).

Some of the advantages of the computer rectification are: speed of execution, accuracy and the fact that the rectified image retains the visual characteristics of the original painting. In Fig. 4c the original light and colour of the pattern have been preserved. Notice, for instance, the interesting shadow line cutting the bottom pattern horizontally.

Furthermore, Fig. 4c shows that two identical instances of the black and white pattern exist in the painting, one before and one behind the central dark circle on which Christ is standing. The farther instance of the pattern is hard to discern in the original painting, while it becomes evident in the rectified view (*cf.* top of Fig. 4c).

3.2. The Shape of the Dome in Raphael's *School of Athens*

The previous sections have demonstrated how, by applying homography transformations on portions of paintings, it is possible to create new and compelling views of interesting patterns that might warrant analysis, both in their own right and to ascertain the lengths to which the artist has gone in constructing the painted space. This section shows that homographies also may be used to analyse the shape of non-planar patterns such as domes and vaults.

Raphael's *School of Athens* fresco (Fig. 5a) owes much of its fame to the great airy space of harmonious architecture inhabited by the renowned philosophers of antiquity, lead by Plato and Aristotle. The lucid, classical forms of the building exude an air of rationality and simplicity. The viewer assumes that the artist has represented the School as a building based on the Greek cross plan that was so admired in the Renaissance. As the Greek cross is characterised by two arms of equal length (Fig. 5b) the quadrilaterals defining the shape of the base (labelled with letters from A to E in Fig. 5b) should therefore be square in the three-dimensional scene. This would also imply that the central dome, whose base is inscribed in the central quadrilateral (denoted with the letter E), must have a circular base. Our analysis proves that these assumptions are not consistent with the geometry of the painting and that the base of the dome is elliptical rather than circular. Alternatively, if we assume that the base of the dome is circular, the arms of the cross would consequently need to be longer than they are broad. Either way, the principles of classical design have been subverted.

A planar homography is employed here to rectify the base of the visible vault (the arm of the cross defined by the quadrilaterals A, E and B) into a rectangle, based

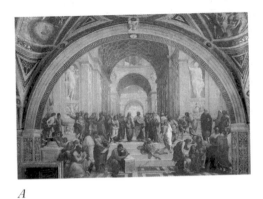

A

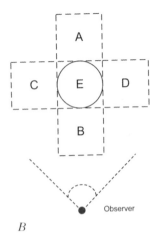

B

C

D

Fig. 5. Analysing the shape of the dome in The School of Athens.

(A) The original fresco: The School of Athens (1510-11), by Raphael. Stanza della Segnatura, Vatican Museums.© Vatican Museums.
(B) The plan of the building appears to be a Greek cross. The circle in the middle represents the base of the central dome.
(C) The rectangular base of the vault is outlined.
(D) The base of the vault has been rectified by using a homography transformation. The top and base quadrilaterals (B and A) have been assumed to be square. However, the central quadrilateral (E) turns out to be a rectangle and not a square as expected. Consequently, the inscribed base of the dome is elliptical rather than circular.

on the assumption that the two quadrilaterals A and B (Fig. 5c) are perfect squares (in the three-dimensional scene).

In this case the homography is defined by the vertices of the three quadrilaterals selected in the original painting (eight points). The computer-rectified image is shown in Fig. 5d. Notice that as the vault lies above the plane of its base it gets warped in an unexpected way.

In Fig. 5d the base of the vault, delineated by the broken lines, is rectangular and the quadrilaterals A and B are perfectly square in their construction. Notice that just imposing that one of the two quadrilaterals, A or B is square implies that the other one is square too. The same does not apply to the central quadrilateral, E.

In order to establish the shape of the central quadrilateral (E) it is sufficient to compute the ratio between its height and its width.

$$\text{Ratio}_E = \frac{\text{height}_E}{\text{width}_E} \tag{1}$$

Therefore, $Ratio_E = 1$ for a perfect square and $Ratio_E \neq 1$ for a rectangular, central quadrilateral.

In our experiment (run on the rectified Fig. 5d) we measured $Ratio_E = 0.877$ which corresponds to a relative error

$$Err = |\ Ratio_E - 1.0\ | = 12.33\ \%. \tag{2}$$

The error $Err \gg 0$ confirms that the quadrilateral E is not a square but a rectangle. Since $Ratio_E < 1$ its base is larger than its height. Therefore, the inscribed curve is *not* a circle but an ellipse, with the ratio between the two diameters being $Ratio_E$.

The careful reader may be concerned about the accuracy of these results. In fact, the accuracy of Eq. (1) depends on how the eight corners of the three visible quadrilaterals A, E and B are selected on the painting. To achieve a high degree of accuracy we chose to select those points by intersecting pairs of straight Canny edges thus achieving a sub-pixel level of accuracy. Furthermore, in order to get a better sense of the accuracy of the results the experiment was repeated for different sets of input vertices obtained by displacing their location by a few pixels.

The relative error in Eq. (2) was found to be consistently larger than 10 per cent, thus confirming the elliptical nature of the central dome. These results were also reproduced by a careful (and lengthy) manual analysis, thus confirming the potentiality of our computer technique.[16]

Since we know from the cartoon for the lower part of the fresco (Biblioteca Ambrosiana, Milan) and the lines incised by the artist in the damp plaster of the wall that Raphael went to enormous trouble to construct the perspective of the School, this deviation is unlikely to have been causal. The move away from strict regularity is of the kind that artists habitually make when they are undertaking the actual painting and trying to make things 'look right' subjectively rather than conforming meticulously to the rules of perspective. It may be that Raphael wanted to pull the space under the dome closer to the central figures of Plato and Aristotle by moving the rear arch of the crossing forward, thus enhancing the paradoxical effect that they are standing under the dome.

4. Exploring the Third Dimension

In the previous sections algorithms have been presented for: evaluating the internal consistency of the geometry of a painting with respect to linear perspective; rectifying and measuring planar surfaces; and estimating distances from planar surfaces (e.g. the height of people). By combining all the above techniques it is possible to create complete three-dimensional models of the painted scenes.[17]

This section presents one of the three-dimensional models that have been constructed and explores the possible ambiguities in reconstruction that may arise. More importantly, three-dimensional reconstruction is used also as a tool to detect and magnify possible imperfections in the geometry of the painting.

4.1. The Virtual *Trinity*

The church of Santa Maria Novella in Florence boasts one of Masaccio's best-known frescoes, *The Trinity* (Fig. 6a).

The fresco is the first fully developed perspectival painting from the Renaissance that uses geometry to set up an illusion in relation to the spectator's viewpoint. Masaccio was the first painter to understand and apply Brunelleschi's rules of linear perspective, and it has been suggested that Brunelleschi was involved in its design. This novel way of creating a three-dimensional illusion on a flat surface was applied by Masaccio in a series of works, including the Brancacci Chapel in Florence, painted in the span of a few years before his early death in 1428.

The *Trinity* has been repeatedly analysed using traditional techniques, but no consensus has been achieved. There have been unresolved disputes about the position of the figures, cross and platform in space, given the lack of a visible floor

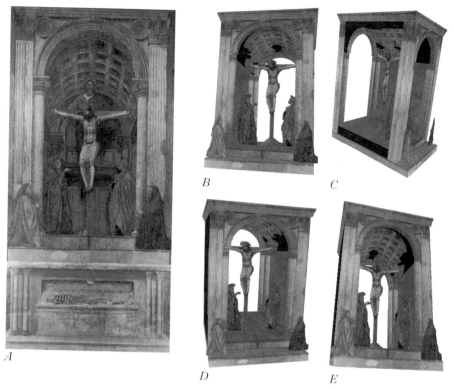

Fig. 6. Three-dimensional reconstruction of Masaccio's Trinity.
(A) The original fresco: The Trinity with the Virgin and St John (c. 1426), 667 x 317 cm, by Masaccio, Museo di Santa Maria Novella, Florence, Courtesy of the Musei Comunali di Firenze.[19]
(B-E) Different views of the reconstructed three-dimensional model of the chapel in the Florentine fresco.

for the chapel. More importantly, it has become apparent that analyses starting with the assumption that the coffers (or the *entablatures* at the top of the nearest capitals of the columns) are as deep as they are wide result in a different format from those that start with the premise that the plan of the chapel is square. Single-view reconstruction algorithms have been applied to an electronic image of the fresco to help art historians reach a consensus over those debated disputes. Views of the resulting three-dimensional model are shown in Figs. 6b-e. The model geometry has been computed and stored in a VRML format that can be displayed, by any of the many existing browsers. The portions of the vault which are occluded by the capitals and by the head of God have been left blank and are shown in black in the illustrations. Although such regions could have been filled,[18] here we have chosen not to do so, in order to highlight the areas that are not visible from the original viewing position.

Ambiguity in Recovering Depth

Since one image alone is used and no scene metric information is known (the chapel is not real), an ambiguity arises in the reconstruction: it is not possible to uniquely recover the depth of the chapel without making some assumptions about the geometry of the scene.

Two plausible assumptions may be made: either the coffers on the vault of the chapel are square or the floor is square. The reconstruction shown in Figs. 7b-e has been achieved by assuming that the vault coffers are square.

Just by looking at the painting one may think that the two assumptions are consistent with each other. Below we demonstrate that that is not the case, the two assumptions cannot coexist, i.e. square coffers imply a rectangular ground-plan and vice versa. Here the two models stemming from the two different assumptions have been readily computed by means of single-view reconstruction algorithms. Once the first model was constructed, the second one was obtained by applying a simple 3D affine transformation, a scaling in the direction orthogonal to the plane of the fresco. The advantage in terms of speed and accuracy over manual techniques is obvious.

The image of the chapel floor and that of the vault pattern shown in Fig. 7 for both cases demonstrates that the square ground-plan assumption yields rectangular coffers and the square coffers assumption yields a rectangular ground-plan.

Because of the lack of visible floor it is not possible to uniquely locate the base of the cross and the human figures. For visualisation purposes, in both models the cross is located at the centre of the chapel and the figures of the Virgin and St John at one quarter of the chapel's depth. Once position of cross and figures has been fixed on the floor their height has been computed consistently, as described in section 2.1.

The number of reconstructions consistent with the original painting is infinite. In fact, different choices of the coffers or ground-plan aspect ratios yield different consistent three-dimensional models. Only two assumptions (square coffers and square ground-plan), from this infinite set, have been analysed here. These seem to be more likely than others, for the following reasons: (1) having a square ground-plan seems to be the natural choice from a design point of view. The artist probably started the design of the chapel by laying down the square foundations, then working out the heights of the columns and finally the rest of the composition. (2) The second assumption, that of square coffers, seems to be more likely from a perceptual point of view. The vault coffers are very visible and it makes sense for the observer to subconsciously assume them to be square and regularly spaced.

At this point new questions arise: Which architectonic structure did the artist want to convey? If he had started by laying down a square base, why would he choose

| *floor:* | *vault:* | *floor:* | *vault:* |
| square ground plan | rectangular coffers | rectangular ground plan | square coffers |

*Fig. 7. Ambiguity in reconstructing the depth of the chapel in Masaccio's Trinity comparing two possible reconstructions from an infinite set of plausible ones. (**Left**) Assuming a square ground-plan leads to rectangular vault coffers and (**Right**) Assuming square vault coffers leads to a rectangular ground-plan, thus demonstrating that ground-plan and coffers cannot be square at the same time.*

rectangular-shaped coffers? Was he aware of the depth ambiguity? Was it done on purpose?

Without exploring the answers in detail here, we suspect that Masaccio began, as most designers would, with the overall shape, and then fitted in the details, and that when he found that his earlier decisions had resulted in coffers that were not quite square (if he noticed!), he decided that they would effectively look square anyway. In the final analysis, visual effect takes over from absolute accuracy. We know, for instance, that Masaccio has intended the circumferential width of the lowest rows of coffers to the left and right of Christ's cross, presumably to avoid visually awkward conjunctions in that area of the painting.

Whatever the reason for Masaccio's ambiguity, the computer analysis performed here has allowed us to investigate both assumptions rigorously, by efficiently building both models, visualising them interactively and analysing the shape of vault and base in three-dimensions.

A Comparison with Traditional CAD Techniques

An earlier three-dimensional reconstruction of the *Trinity* can be found in DeMey, (1993).[20] The three-dimensional model constructed in that work was realised using Computer Aided Design tools. The geometric shape of the scene was constructed by making use of the painting geometry and a number of inevitable yet arbitrary assumptions that find little justification in the original painting.

With our technique the three-dimensional geometry is extracted directly and exclusively from the image plane and only the objects for which enough geometric information is present in the painting are reconstructed.

In general, architectonic elements in the paintings contain much greater geometrical information (e.g. parallelism and orthogonality of lines and regularity of patterns) than smooth surfaces such as human bodies. The algorithm presented here is capable of constructing architectonic elements up to a very limited number of degrees of freedom. Furthermore, the effect of the remaining ambiguities can be rigorously analysed. In fact, our mathematical tools have enabled us to parametrise the entire infinite family of three-dimensional models that are geometrically consistent (producing the same image from the same vantage position) and satisfy all the assumptions made (as in the case of Masaccio's *Trinity*).

Instead, the human figures are characterised by much less purely geometrical information. Therefore, their reconstruction is subject to a much greater number of degrees of freedom[21] thus leaving us with greater choices about the possible shapes of the human bodies in the painting. Because of this fundamental uncertainty, in this work we have chosen to approximate human bodies with flat cut-outs. It is our intention to investigate the use of shading, texture[22] and contours to try and constrain the reconstruction of smooth surfaces and, possibly, come up with parametric models of clothed human figures of manageable size.

Generally, traditional CAD techniques do not allow the level of reasoning which so profoundly characterises our methods. The unavoidable assumptions made during the reconstruction process are made explicit in our system and the effect of removing or adjusting them is analysed by efficiently assessing the consequences directly on the reconstructed three-dimensional model.

Finally, not only the geometry, but also the appearance (the texture) of the final model is extracted directly from the image of the fresco, thus achieving a superior level of photorealism, as supposed to the often artificial look of synthetic CAD models in Art History.

5. Conclusion

This paper has presented a number of computer algorithms for: assessing the internal consistency of the geometry in a painting and its conformity to the rules of linear perspective; generating new views of patterns of interest; reconstructing occluded areas of the painting; measuring and comparing object sizes; constructing complete three-dimensional models from paintings; exploring, in a systematic way, possible ambiguities in reconstruction, and, finally, assessing the accuracy of the reconstructed three-dimensional geometry.

The presented algorithms, heavily based on the use of algebraic projective geometry, are rigorous and easy to use. Art historians may use them for a more systematic and efficient analysis of works of art that employ systematic means for the construction of space.

The validity of our approach has been demonstrated, whenever possible, by comparing the computer-generated results to those obtained by the traditional manual procedures employed by art historians.

Furthermore, this paper has proven that computer tools, built on top of a strong projective geometry basis, can answer questions such as: How correct is the perspective in any painting posing strong perspectival clues, such as Signorelli's *Circumcision*? What does the pattern on the floor in Domenico Veneziano's *St Lucy Altarpiece* look like?

The ability to turn flat paintings into interactive three-dimensional models opens up a new and exciting way of experiencing art with new levels of vividness and historical awareness. Inverting the painting process and navigating inside three-dimensional scenes may be used for teaching purposes. Art students and aficionados may be able to understand better the power of linear perspective by interacting with three-dimensional objects rather than by just looking at the painting. Art historians will be better able to judge the levels of concern of artists with perspectival accuracy and to analyse possible reasons for their departure from strict obedience to geometrical rules. The relationship between the 'ideal' viewpoints and those available to the spectator in actual locations, such as S. Maria Novella, the site of Masaccio's *Trinity*, may be easily explored by using these tools. Another interesting application is to set the paintings in virtual reconstructions of their original locations (if known).

A new, XML-based visualisation tool has been presented where the user can navigate inside a virtual museum and, seamlessly fly from the museum to the paintings 3D scenes and back. Our techniques are currently being employed in the *Empire of the Eye* project under design for the National Gallery in Washington (www.nga.gov). *Empire of the Eye* intends to build upon and extend *Masters of Illusions*.[23] One of the project's aims is that of interactively teaching about the power of linear perspective in conveying a three-dimensional illusion on a flat surface. The tools described in this paper prove invaluable for constructing interactive three-dimensional environments from historical paintings.

Future Work

The focus of this paper has been the geometry of paintings, therefore, our examples have considered works from the Italian Renaissance and seventeenth-century Holland, two of the eras in which the rules of linear perspective were most rigorously applied. The potential of this method for viewing of paintings *in situ* has already been suggested.

Currently our interests focus on a very different aspect of painting, i.e. the management of light and shading. We are investigating the use of light, shading and colours in paintings and exploring possible ways to model those effects in a rigorous and systematic way.[24]

The relationship between the distribution of light, shade and colour in paintings and the scientific notions of light available to the artists (from Aristotle to Newton and later) is a matter of complex historical debate.[25] It should be possible to take some of the artists who adopted a consciously experimental approach to light and colour, such as the Impressionists and Neo-Impressionists and to place their creations in dialogue with the techniques of computer vision and computer graphics.

Furthermore, some recent work of ours has dealt with the analysis of the accuracy of painted mirrors[26] and the implications on Hockney's recent theories.[27]

Discussion

When looking at photographs of a scene, visual cues such as converging straight lines, shading effects, receding regular patterns, shadows and specularities are processed by the brain to retrieve consistent information about the surrounding environment.

The same visual cues have over the years come to be employed by artists in their paintings. However, works of art are rarely designed to conform precisely to a set of optical rules and are not presented as scientific theorems. Thus, the visual signals might not be consistent with each other. As much psychophysics research shows,[28] our brain is capable of neglecting conflicting cues, and slightly inaccurate perspective or shading may still convey the desired three-dimensional illusion. Also, it may be apparent that breaking the rules creates a forceful artistic effect.

A number of interesting questions arise: Which perceptual cues are most important to the three-dimensional illusion? To what extent do humans forgive wrong cues? How much does each artist make use of visual cues? Which ones? How about abstract or cubist paintings? These points may lead the way to further interesting psychophysical speculations in which science and art can play a fundamental role.

It is the authors' opinion that computer graphics, computer vision, art history and perceptual psychology and neurology, each of which are well-distinguished disciplines with their own aims and motivations may learn from and be enriched by the others. Furthermore, the tools developed in one area may be transferable productively to another. The present paper is but a step in that process.

Acknowledgements

The authors would like to thank Ian Reid and David Liebowitz from the University of Oxford, Luc van Gool from the Katholieke Universiteit of Leuven and Steve Seitz from the University of Washington for their help and suggestions and Matthew Uyttendaele, Rick Szeliski and P. Anandan from Microsoft Research for

useful and inspiring discussions and for providing the XML-based visualisation tool. Also thanks are due to the collaborators of the *Empire of the Eye* project: Joseph Krakora, Jay Levenson and Curtis Wong.

Notes and Bibliography

1 A longer and more detailed version of this paper is available at www.chart.ac.uk.

2 Kemp, M. (1989), *The Science of Art*, New Haven and London: Yale University Press.

3 Field, J. V. (1997), *The Invention of Infinity, Mathematics and Arts in the Renaissance*, Oxford University Press; Semple, J. G., Kneebone, G. T. (1979), *Algebraic Projective Geometry*, Oxford University Press; Taylor, B. (1715), *Linear Perspective*, London.

4 Faugeras, O. D. (1993), *Three-Dimensional Computer Vision: a Geometric Viewpoint*, MIT Press; Hartley, R. I., Zisserman, A. (2000), *Multiple View Geometry in Computer Vision*, Cambridge University Press; Debevec, P. E., Taylor, C. J., Malik, J. (1996), 'Modeling and rendering architecture from photographs: A hybrid geometry- and image-based approach', *Proceedings ACM SIGGRAPH*, pp. 11-20.

5 Criminisi, A. (2001), 'Accurate visual metrology from single and multiple uncalibrated images', *Distinguished Dissertation Series*, London: Springer-Verlag; Horry, Y., Anjyo, K., and Arai, K. (1997), 'Tour into the picture: Using a spidery mesh interface to make animations from a single image', *Proceedings of the ACM SIGGRAPH Conference on Computer Graphics*, pp. 225-232.

6 Kemp, M. (1989), *The Science of Art*, New Haven and London: Yale University Press.

7 De Mey, M. (1993), *Perspektief in 3-D*, Gent Universiteit, 8ste jaargang (3), pp. 14-17.

8 Criminisi, A., Kemp, M., Zisserman, A. (2003), 'Bringing pictorial space to life: computer techniques for the analysis of paintings', *Digital Art History? Exploring Practice in a Network Society. The Online Proceedings of the Eighteenth Annual CHArt Conference Held at the British Academy, 14-15 November 2002*, Vol. 5, Edited by A. Bentkowska, T. Cashen and J. Sunderland, www.chart.ac.uk (active 21 July 2003).

9 Criminisi, A. (2001), 'Accurate visual metrology from single and multiple uncalibrated images', *Distinguished Dissertation Series*, London: Springer-Verlag.

10 Kemp, M. (1989), *The Science of Art*, New Haven and London: Yale University Press.

11 Piero della Francesca, [1474], *De Prospectiva Pingendi*, Firenze, Italy, (Reproduced by ed. Sansoni Edizione Critica, 1942).

12 Criminisi, A., Reid, I., Zisserman, A. (1999), 'A plane measuring device', *Image and Vision Computing*, 17: 8, pp. 625-634.

13 Kemp, M. (1989), *The Science of Art*, New Haven and London: Yale University Press.

14 Criminisi, A. (2001), 'Accurate visual metrology from single and multiple uncalibrated images', *Distinguished Dissertation Series*, London: Springer-Verlag, p. 33.

15 Kemp, M. (2000), *Visualizations: the nature book of art and science*, Berkeley and Los Angeles, California, USA: The University of California Press; Kemp, M. (1989), *The Science of Art*, New Haven and London: Yale University Press.

16 A more complete uncertainty analysis may be performed by employing the statistical techniques described in Criminisi, A., Reid, I., Zisserman, A. (1999), 'A plane measuring device', *Image and Vision Computing*, 17: 8, pp. 625-634.

17 See Criminisi, A. (2001), 'Accurate visual metrology from single and multiple uncalibrated images', *Distinguished Dissertation Series*, London: Springer-Verlag, for details about the reconstruction algorithms.

18 As described in Criminisi, A., Kemp, M., Zisserman, A. (2003), 'Bringing pictorial space to life: computer techniques for the analysis of paintings', *Digital Art History? Exploring Practice in a Network Society. The Online Proceedings of the Eighteenth Annual CHArt Conference Held at the British Academy, 14-15 November 2002*, Vol. 5, Edited by A. Bentkowska, T. Cashen and J. Sunderland, www.chart.ac.uk (active 21 July 2003).

19 The reconstruction algorithm is described in Criminisi, A. (2001), 'Accurate visual metrology from single and multiple uncalibrated images', *Distinguished Dissertation Series*, London: Springer-Verlag.

20 De Mey, M. (1993), *Perspektief in 3-D*, Gent Universiteit, 8ste jaargang (3), pp. 14-17.

21 Zhang, L., Dugas-Phocion, G., Samson, J.-S., Seitz, S. (2001), 'Single view modeling from free-form scenes', *Proceedings of the Conference on Computer Vision and Pattern Recognition*, Kauai Marriott, Hawaii.

22 Criminisi, A., Zisserman, A. (2000), 'Shape from texture: homogeneity revisited', *Proceedings of the Eleventh British Machine Vision Conference*, Bristol, pp. 82-91.

23 Burke, J. (1991), *Masters of Illusion*.

24 Nayar, S., Narasimhan, S. (1999), 'Vision in bad weather', *Proceedings of the Seventh International Conference on Computer Vision*, Kerkyra, Greece, pp. 820-827.

25 Kemp, M. (1989), *The Science of Art*, New Haven and London: Yale University Press.

26 Criminisi, A., Kemp, M., and Kang, S. B. (2003), 'Reflections of reality in Jan van Eyck and Robert Campin', *Measuring Art: A Scientific Revolution in Art History*, Paris.

27 Hockney, D. (2001), *Secret Knowledge: Rediscovering the Lost Techniques of the Old Masters,* Viking Press.

28 Blake, A., Bultoff, H. (1990), 'Does the brain know the physics of specular reflection?' *Nature,* 343 (6254), pp. 165-168; Bulthoff, H., and Mallot, H. A. (1987), 'Interaction of different modules in depth perception', *Proceedings of the first International Conference on Computer Vision,* London, pp. 295-305.

Enhancing a Historical Digital Art Collection:
Evaluation of Content-Based Image Retrieval on Collage

Annette A. Ward, Margaret E. Graham, K. Jonathan Riley

and Nic Sheen

Growing numbers of users are visiting museum, library, archive, and other cultural heritage digital image collections on the Internet. Searching for images using traditional text-based methods, however, can be challenging. Enhanced software that retrieves images by colour, texture, and shape may be increasingly useful when words do not provide the desired results. Enhanced software can also provide a novel way to browse through a database.

Content-based image retrieval, or CBIR, is a computer-derived technique for retrieving images based on elements such as colour, texture, and shape. It uses features of a selected painting, print, drawing, or other object to find visually similar images. CBIR locates matches in a collection regardless of whether they share key words with the original image. Retrieval of images by keywords, subject descriptors, or indexing terms is not CBIR, even if the keywords describe the content of the image.

As part of a research project funded by Resource: The Council for Museums, Archives and Libraries (CMAL/RE/103), commercial CBIR software was added to the digital image collections at three institutions: the British Library, the British Broadcasting Corporation (BBC), and Collage (http://collage.cityoflondon.gov.uk), The Corporation of London Guildhall Library and Guildhall Art Gallery website. The goal of this research was to assess the effectiveness of content-based image retrieval through a systematic evaluation while providing users with accessibility to images independent of applying indexing terminology. This paper explains how content-based image retrieval was integrated on the Collage site and highlights selected results from the online user questionnaire.

Selection of Operational Sites and Collaborators

Of critical importance in meeting project objectives was selecting collaborative

partners that met specific criteria that included a digitised image collection of at least 10,000 images, a progressive outlook toward information retrieval, and a willingness to adopt new technology. Since technical expertise and valuable data were shared, it was important to establish a relationship based on shared goals, outcomes, and trust. Confidentiality agreements and consensus regarding delegation of work were also required.

It was also important that each collaborator benefit from the partnership. In this instance, the Guildhall enhanced their reputation by offering advanced search capabilities. In addition, demographic information supplied by respondents to the online questionnaire provided a user profile that helps Guildhall staff meet client needs and develop services and products. It was especially important that the Guildhall did not incur additional expenses for any of those activities. Costs for implementing the project were shared between the Institute for Image Data Research (IIDR) and iBase, freeing Guildhall resources to accomplish their original mission. Data collected regarding the users' assessment of Collage and content-based image retrieval provides essential information for researchers and software developers to evaluate technology that refines searches. This, in turn, is important to the future of information retrieval.

The original medieval library at the London Guildhall was founded in the 1420s through the will of Richard Whittington. The modern institution dates from 1824 and includes the Print Room, the Guildhall Library, and the Guildhall Art Gallery. The Guildhall Art Gallery houses over 4,000 paintings of which approximately 250 are exhibited at any one time. Together, the collections from the Print Room and the Guildhall Art Gallery present an extensive and comprehensive view of London and the foundation for Collage. The collection includes paintings, engravings, maps, photographs, prints, and drawings. Most relate to London from the sixteenth to the twentieth centuries. There are extensive collections of satirical prints, panoramas, and images related to social themes. An unrivalled collection of London maps dating from the sixteenth century to the present includes parish, ward, borough, and thematic types.

Collage was conceived in 1995 in order to digitise the collection of the London Guildhall Library. By 1997 the database contained 36,000 images. The next phase of the project delivered public access to the images within the Print Room at the Guildhall Library via a simple user interface. This in-house database was redesigned for the Internet at the end of 1998. At the time, Collage was the largest digital imaging project in Europe. Due to copyright restrictions, visitors to the online version of Collage may access 22,400 images of the total 36,000.

iBase has provided the software for Collage since its inception, working closely with the London Guildhall Library to provide technical expertise. iBase Image Systems was formed in 1992 as the result of collaboration between the founding directors and the National Museum of Photography, Film and Television to provide an image database for an early photographic collection of 1920s racing cars for Zoltan Glass. iBase developed a revolutionary hard disk storage solution that was adopted by

other UK heritage institutions, including the British Library and the Natural History Museum.

The Institute for Image Data Research at The University of Northumbria in Newcastle upon Tyne was established in 1997 as a multidisciplinary research institute integrating researchers from computing, information and library management, psychology, art history, philosophy, apparel marketing, business and management, and engineering to study the relationships between images, computer technology, and people. Research has investigated aspects of special relevance to art history including: image retrieval; how people search for, retrieve, and use images; impact of digital images on art historians; developing and testing software for retrieving trademark and historic watermark images; and assessing the feasibility of applying content-based image retrieval software to a variety of applications such as the one described here.

Technical Application of Content-based Image Retrieval Software to Collage

Application of content-based image retrieval software to the web-based version of Collage required a smooth transition with no confusion for users and no disruption to the standard services. Additionally, it was important to establish use of CBIR as voluntary, provide a simple mechanism for users to test CBIR within the Collage website, allow users the option to specify preferences on search parameters, return results of the CBIR search in a format familiar to Collage users, encourage users to complete the online questionnaire, and develop a system that would work with common browsers.

Development of the site also imposed technical considerations and constraints. For example, regular activities of the London Guildhall Library could not be disrupted by the project, service of the Collage site could not be adversely impacted during CBIR software application, performance of the Collage site could not be diminished by introduction of CBIR, the user interface had to be independent of the CBIR software allowing the potential for testing different types of CBIR software, and the CBIR software had to be held on the Institute's server.

System Design

Application of the CBIR software to Collage comprised five integrated stages. General testing of the site was simplified because of the modular architecture of the computer system whereby components could be developed and tested before integrating the complete system.

Fig. 1. A traditional Collage search must be conducted before beginning a CBIR search (Image courtesy of Corporation of London, Library and Guildhall Art Gallery Department).

Creating the Database

Approximately 31,000 images on six CDs were processed. Although the entire Collage database consisting of 36,000 images is used within the London Guildhall on its in-house computer system, only 22,400 images are used on the online database because of copyright restrictions.

Designing the Interface to Initiate the CBIR Search

Content-based image retrieval software from Virage® was linked to the Collage system to perform image analysis and image comparison. Image analysis was executed only once for the entire image database resulting in feature vector information, a mathematical representation of the visual content of an image. Image comparison for this database involved assessing three feature vectors (colour, texture, and shape) resulting in a score that quantifies image characteristics. Sizes of the feature vectors vary slightly but are approximately 1.3 KB for each image, producing a database of over 44 MB for all of the images and taking several hours to generate.

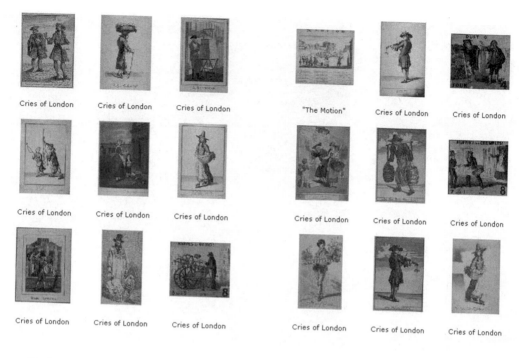

Fig. 2. A text-based search for 'Cries of London' yielded 35 pages of which two are shown (Image courtesy of Corporation of London, Library and Guildhall Art Gallery Department).

Conducting a CBIR Search

In order to activate content-based image retrieval, the user began with the traditional Collage search mechanism (Fig. 1). A word was entered in the search box or one of several search categories was selected. When 'Cries of London' was entered in the search box, the text-based search yielded 35 pages, of which two are shown in Fig. 2.

The communication pattern in a traditional search between the user and the Collage server was a fairly simple one, however, the addition of CBIR software made communication a bit more complicated. When the user selected a single image for closer inspection, a 'Standard Visual Search' or an 'Advanced Visual Search' could be conducted using the links below the image (Fig. 3). If a user conducted a 'Standard Visual Search,' the search parameters were set at default values. Colour was set at 1, visual texture at 60, and shape at 30 out of a possible 100. Testing of the 'Standard Visual Search' determined optimum values for producing the most desirable matches. Since many images in Collage are not colour images, these settings were found to be most effective.

When an 'Advanced Visual Search' was conducted, the user ranked 'colours in the image,' 'visual texture in the image,' and 'shapes in the image' on a five-point

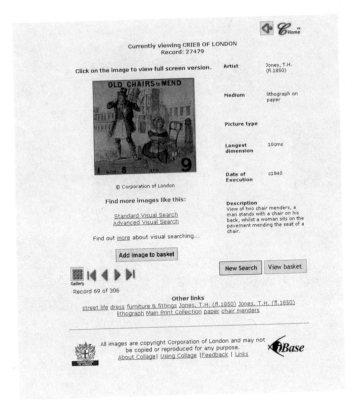

Fig. 3. A Standard Visual Search or an Advanced Visual Search may be conducted once a specific image has been selected from a traditional Collage search (Image courtesy of Corporation of London, Library and Guildhall Art Gallery Department).

Likert-type scale indicating the characteristic as 'not at all important' to 'very important'. Values were assigned to each button on the scale with 'not at all important' set at 1, and subsequent buttons set at 20, 40, 60, and 80. The software requires that each variable has a value greater than zero, thus 1 is assigned to indicate practically no importance.

When CBIR was initiated, the identification number (ID) was read and the corresponding weights for colour, texture and shape were sent to the IIDR server (Fig. 4). The feature vectors for the image were extracted from the database. Using the weightings compared with all of the other image feature vectors in the database, a list of distance measures was produced. The IDs were then sorted to create a list of image IDs in order of similarity. Searching all the images and producing the results took about ten seconds. In order not to affect the general performance of Collage, the CBIR engine was placed on a second server. This moved a heavy processing load away from the main Collage database, maintained exclusively by iBase, and shifted maintenance and monitoring of the CBIR segment to the Institute for Image Data Research.

Fig. 4. Logical design of the CBIR/Collage system illustrating a text-based search (A) and the distribution of CBIR processing between the Collage website and the Institute for Image Data Research at University of Northumbria (B).

Displaying Results from the CBIR Search

At the end of a CBIR search, measures for the entire Collage database were sorted in ascending order. However, only the first eighteen images were collected for potential viewing and only eight in addition to the original image were displayed (Fig. 5). The 10,000 images for which the Guildhall does not hold the copyright were excluded from transmission over the web. A surplus of returned images insured a sufficient number for viewing when non-copyrighted images were filtered out of the returned images. Additionally, because Collage displayed nine images with its traditional searches, it was decided that the CBIR results page should use the same nine-image format. Four pages of results from a text-based search are compared with actual CBIR results in Fig. 6.

Testing on the Web

During project development, Collage was made available on the Institute's network so that project and other researchers could test and evaluate the software. While

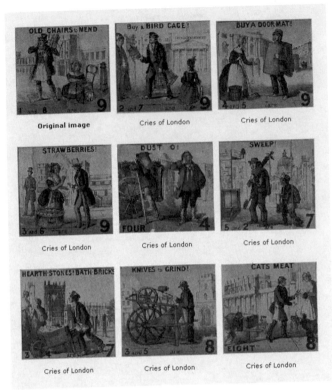

Fig. 5. Results of the CBIR search are displayed using a gallery format similar to the traditional Collage search (Image courtesy of Corporation of London, Library and Guildhall Art Gallery Department).

the computer system was constructed, the online questionnaire was developed. Questions were devised to assess CBIR functionality and satisfaction, the Collage service, and demographic information about the users. The format of the questionnaire was designed to match the original Collage site and was pilot tested on different browsers to ensure compatibility.

Results and Analysis

Recruitment to the site was conducted in November and December 2000 by distribution of brochures at classes at Northumbria University and at professional conferences. Once the initial recruitment phase was complete, the site was left undisturbed while data collection progressed. Responses to the questionnaire were collected online and were transferred to a Microsoft Excel® spreadsheet and input into a file for analysis using SPSS 10.0. Frequencies, percentages, and means were computed on the questionnaire. Results presented here include responses received up to early February 2002.

Fig. 6. Four pages of a text-based search are compared with one page of CBIR results (Image courtesy of Corporation of London, Library and Guildhall Art Gallery Department).

Respondents

The 181 visitors to the site who completed the questionnaire were almost evenly divided between females (81 or 45 per cent) and males (84 or 46 per cent), with 9 per cent not responding. Age was distributed throughout the categories with the greatest percentage (29 per cent) aged 46-55. Similar numbers of respondents, 14 per cent, 18 per cent, and 13 per cent, respectively, were reported for age ranges 26-35, 36-45, and 56-65. Over half of the respondents indicated having an undergraduate or post-graduate degree with nearly a third of the respondents possessing a postgraduate degree. Students comprised 16 per cent of the respondents, 39 per cent reported full-time employment, and 22 per cent reported they were retired.

Respondents reported a range of professions with no apparent groupings emerging. 'Retired' (11 per cent) and 'education' (10 per cent) were the most frequently reported categories. Sixty-two per cent of the respondents were UK residents with 22 per cent USA residents. However, there were also visitors from Australia, Canada, France, Germany, Austria, Poland, Portugal, and even Nepal.

Over a third (38 per cent) of the respondents had visited the Collage site before and

about half reported using the Internet two or more times a day. Twenty-two per cent reported finding Collage through a link from another site, while the same percentage (around 17 per cent) found it through a web search, were told about it, or found it by accident. Visitors to the Collage site came for various reasons. About one third (34 per cent) came just to look, about one third came to look for a particular print, and about one-third came to research the art collection. Some came for more than one reason.

Ratings of CBIR

Respondents indicated that nearly half (48 per cent) of all the images retrieved by the CBIR software were good matches to the original, whereas about 39 per cent of the images were not. CBIR software returns images in descending order of nearest matches. Thus, it is not surprising that the number of respondents who indicated images were a good match, generally decreased in descending order for images 1 through 8.

Ease of Visual Image Search

The Standard Visual Search was conducted by 74 per cent of the users and 37 per cent conducted the Advanced Visual Search. Some did both. Over 85 per cent of the users 'agreed' or 'strongly agreed' the search was fast and easy to use. Although over 50 per cent concurred that the number of images returned was adequate, nearly a quarter (23 per cent) 'disagreed' or 'strongly disagreed'. This confirms results of another question that asked respondents about the number of images they preferred returned. In that question, almost half of the users (49 per cent) preferred more images returned with nearly 24 per cent wanting more than eighteen.

Usefulness of Visual Image Search

There were some interesting results regarding the usefulness of the visual image search. Forty per cent of the users 'agreed' or 'strongly agreed' that they found what they wanted by using the visual search, and 56 per cent responded that results of the search met their expectations. Over 65 per cent indicated results were useful. Of special importance is the rating regarding whether the respondents would like to use the visual image search again. Nearly 80 per cent responded positively and only 10 per cent disagreed.

Satisfaction with Visual Image Search

Nearly half of the respondents (48 per cent) 'agreed' or 'strongly agreed' that the visual image search was better than a word search. Only 16 per cent of respondents

provided a negative rating of this item. About half (52 per cent) were satisfied with the results. Over three quarters (79 per cent) of the respondents indicated that results were interesting and 73 per cent of the users responded that the visual image search was a good method to retrieve images. Approximately 52 per cent 'agreed' the search was fun to use as compared with the 44 per cent who were negative or neutral. Clearly, reaction is mixed; however, none of the respondents indicated they 'strongly agreed' with the statement that the search was fun to use.

Results taken alone may not portray an accurate picture of the usefulness of the CBIR technology. Although respondents reported CBIR was inconsistent in retrieving similar images nearly 40 per cent of the time, respondents also indicated results were interesting and CBIR was good for image retrieval. Subjects for this study indicated value in using the technology even when the retrieved images were not always 'similar'.

Conclusions and Recommendations

Searching digital images will become more challenging as collections and users continue to increase. Growing collections necessitate image retrieval that expands search capability beyond traditional word-based indexing. Content-based image retrieval offers a solution and has great potential. With traditional searching, the end user may not always be able to define the image for which they are searching. Perhaps the user's language is different from that used in the text-descriptors of the image collection, or the user may be challenged with learning differences that make using indexing terms difficult. With respect to new applications, visual searching may be useful to aid indexing of large collections. Simplifying cataloguing by identifying similar images may be an economical application.

It may be necessary for computer technologists to rethink how they evaluate the success of CBIR. Mathematical modelling of the similarity of retrieved images may not present the best picture. End-user evaluations are critical to evaluating enhanced technology.

Enhancements to CBIR are warranted. Allowing the user to specify the number of returned images from the CBIR search will provide him or her with the opportunity to peruse a greater selection of items. The ability to save the search criteria for future referral will also be important. Combining the option of using text-based descriptors with CBIR can provide an innovative way of image retrieval that integrates two strong retrieval devices. Additionally, using CBIR technology on areas of an image to extract specific elements would be an exciting advance, and a useful tool.

Those 'serendipitous' results that often displease the computer programmer, may be appreciated by end users. An artist explained that if she wanted the exact image back, she wouldn't do a CBIR search; she would stick with what she had in the first place. Variation of returned images may be desirable. CBIR may supply the user

with alternative images that may stimulate creative thought and inspiration, and may lead the user along a different search and, ultimately, a more productive path.

Abstracts

History of Art in the Digital Age: Problems and Possibilities

William Vaughan

Abstract

This paper aims to provide a broad overview on the impact of computers on the study of the history of art. It begins by considering the nature of the information technology revolution, exploring the often-made analogy between it and the 'Gutenberg' revolution brought about by the development of the printing press. Like Gutenberg, the IT development is technologically driven. However it is driven to a different end, one that emphasizes flexibility as well as dissemination. This flexibility can be a two edged sword. While it enables many new possibilities, it also seems to encourage a more fragmentary and iterative approach to study; to the preference of information over knowledge. It remains, however, something of an open question whether this new approach is a necessary consequence of the structure of the new technology being made available or whether it is more a product of that wider intellectual change that has grown with the emergence of post-modernist discourses. I would argue that the latter is the case, and that the fragmentary tendencies that can be accommodated by the new technology can also be countered by those who wish to do so. The computer has developed in the way it has as a result of consumer demand. It is up to those who wish to make different demands to feed these into the technological processes as they are expanded and modified. The paper also looks more specifically at issues that particularly affect the study of images, considering both the potential provided by the digital image for new forms of exploration and analysis, and the new opportunities that are emerging via the World Wide Web.

Keywords: Art History, Knowledge, Information Technology, Digital Image.

Animating Art History: Digital Ways of Studying Colour in Abstract Art

Mary Pearce

Abstract

The study of art history has been greatly enriched through the possibilities offered by digital media. Multimedia particularly, offer the capacity to combine interactivity, a graphic interface, sound and animation and organise information in a matrix of cross-references. The project demonstrated here is an analytical study of the role of colour in early twentieth century abstract art, created as a multimedia presentation. The focus is on paintings from three distinct eras using the work of

Orphist, Bauhaus and Abstract Expressionist artists as examples. In keeping with the methodology of these painters, multimedia were chosen to illustrate inter-related themes of music, calligraphy, visual poetry and issues of time and space. Hence this subject matter and period within modernism were suited to the advantages of multimedia, the user can grasp both the technical qualities of colour as a sensual experience, and approach the analysis of paintings through interactive participation. Overall, this means of presentation has proved a fruitful way to broaden the perception of colour and can be adapted for use in art schools, gallery situations or distance learning courses. The paper draws mainly on sections of a CD-ROM that discuss the work of Paul Klee in order to demonstrate the flexibility of multimedia, and suggest some advantages this might have for the study of art history in the digital era.

Keywords: Colour, Abstract Art, Digital Analysis, Multimedia.

The Cathedral as a Virtual Encyclopaedia: Reconstructing the 'Texts' of Chartres Cathedral

Stephen Clancy

Abstract
The project begins with the notion that traditional methods of presentation and study – e.g. the art-historical slide lecture – can only hope to summarise abstractly the dynamism of the Gothic cathedral. The Gothic cathedral functioned as an encyclopaedia of late medieval humanistic and spiritual concerns – a cultural 'text' that was both 'written' and 'read' by its varied users. We attempt to 'read' this encyclopaedia today in order to understand the religious beliefs, cultural values, and secular practices encoded within it. But we view the cathedral and its environment through modern tourist and commercial lenses, instead of reading their significance through the lens of medieval cultural attitudes. In addition, slides and photographs treat the cathedral merely as a series of static, two-dimensional visual compositions, devoid of spatial continuity, and divorced from the urban and social contexts that gave it meaning. These modern images are also unable to recreate the original appearances of these walls and spaces, in part because the cathedral's structure, imagery, and furnishings have changed or vanished over time. But just as importantly, there was in effect no 'original intended appearance' of the cathedral and its urban environment. Instead, the cathedral acted as constantly changing environment for imagery, devotional ceremonies, and secular practices, adapting itself to the different audiences and occasions it served and the different events that echoed within the bishopric it ruled.

The project uses innovative digital technologies to (1) simulate the spatial contexts and continuities both outside and inside the present-day cathedral; (2) simulate the thirteenth-century physical appearances of Chartres Cathedral and its urban and rural contexts; (3) provide an interactive means of 'experiencing' both the twenty-first and-thirteenth century appearances and contexts; and (4) allow the

cathedral and its environment to be viewed through the lens of the varied cultural attitudes of thirteenth-century Chartres. The project uses over 1,600 digital images, QuickTime panoramas, Photoshop reconstructions of these panoramas, and an interactive interface created with Director. Fundamentally, my project seeks to integrate traditional humanities scholarship and teaching with state-of-the-art technologies that are revolutionising the ways in which a twenty-first-century population accesses cultural objects.

Keywords: Chartres Cathedral, Digital Visualisation, QuickTime® VR Panorama.

With Camera to India, Iran and Afghanistan: Access to Multimedia Sources of Explorer, Professor Dr Morgenstierne (1892–1975)

Wlodek Witek

Abstract
This project is concerned with the archive of the Norwegian linguist and explorer Professor Georg Morgenstierne (1892–1975). The digitised archive has been made available at the National Library of Norway's website (www.nb.no/baser/morgenstierne/). This concludes nearly four years of research by a small team from the University of Oslo and the National Library. The material comprises over 3000 items (photographs, moving images, audio and a selection of drawings, sketches and notes) from Morgenstierne's travels to South Asia: Sri Lanka, India, Pakistan, Afghanistan and Iran.

The uniqueness of this archive lies in the audio-visual records, especially those from 1929, of the previously undocumented culture of the tribes living in the secluded valleys of what is today Pakistan, the area of Chitral, near the border with Afghanistan. Some of these tribes retained the ancient religion and for centuries resisted (also through armed struggle) Islamisation from both Afghanistan and India (Pakistan). The once large area of Kafiristan was suppressed by the Emir of Afghanistan following his invasion of 1896 which also wiped out most artistic symbols that the people there made over centuries.

What prompted our project in 1998 was the fact that there was only one person left in Norway who knew the content and value of the archive and was concerned about the future of this heritage. This person is no longer with us today, but we have managed to finish the work on time to save these important records from oblivion. Not only has the archive been digitised and preserved, but also analysed, the content of individual records, exact dates and places identified and classified. Researchers have free access to this material. We hope that one day the indigenous people will also gain access.

Keywords: Georg Morgenstierne, Chitral, Digitisation, Multimedia.

Towards a Yet Newer Laocoon. Or, What We Can Learn from Interacting with Computer Games

Michael Hammel

Abstract
Interactive works of art pose special problems. An interactive artwork can only be interpreted through interaction, either first-person or as a bystander. It is obvious that the experience differs between the two positions: one acts and the other watches the acting. The question is whether it is possible to extract the artwork from the interaction with it, let alone differentiate between two kinds of interaction: the beholders' interaction with the artwork and the interaction taking place between the beholders.

This leads to further questions, as to how the interactive artwork is to be interpreted when the spectator has left it, or has changed it? Is it possible to interpret interactive artworks without interacting with them? Is it at all possible to interpret artworks through interaction, and thereby accept the interpretation from a distracted interpreter? If you are, for example, given a detailed account of one level of the interactive game *Doom*, you will never make it to the end, or will be too busy winning to watch the details.

The answers to these questions, I argue, lie in the addition of an 'interactivity-theory' to traditional aesthetics. The concept of interactivity, based on experiences of computer games and web design, in many ways counters Kantian aesthetics. This may equip the art historian with tools to take up the challenge presented by interactive artworks, as well as contribute to a different view of computer games and electronic visual culture.

Keywords: Computer Games, Interactive Computer Art.

Digital Arts On (the) Line

Dew Harrison and Suzette Worden

Abstract
This paper considers recent trends in the digital arts through an examination of projects associated with the Watershed Media Centre, Bristol, UK.

Electric December, an online advent calendar, is an annual event started in 1999. It is a project that promotes local interests and explores the ways in which creativity can be part of a community-building process in a specific region. In this paper we examine how the project has evolved over three years, technically and through its social agenda.

We also present the outcomes of a call for contributions to an online exhibition of

digital arts. *Net_Working* was an online exhibition of works by national and international artists, also on view in Watershed's Digital Café. The call brought a response from over 300 artists. How the work has been chosen and categorised for the user, as well as an indication of the range of work available will be presented. This project will be compared to a previous exhibition, held in November 2000 at the same venue. During the intervening period Watershed has developed new strategies for the presentation and introduction of online work to its visitors. How these examples contribute to our understanding of changes in the curation of digital arts is the subject of the final section of the presentation.

Keywords: Electric December, Net_Working, Digital Art, Online Exhibition, Online Curation, Watershed Media Centre, Bristol.

Bringing Pictorial Space to Life: Computer Techniques for the Analysis of Paintings

Antonio Criminisi, Martin Kemp and Andrew Zisserman

Abstract

This paper explores the use of computer graphics and computer vision techniques in the history of art. The focus is on analysing the geometry of perspective paintings to learn about the perspectival skills of artists and exploring the evolution of linear perspective in history. Algorithms for a systematic analysis of the two- and three-dimensional geometry of paintings are drawn from work on single-view reconstruction and applied to interpreting works of art from the Italian Renaissance and later periods. As a perspectival painting is not a photograph of an actual subject but an artificial construction subject to imaginative manipulation and inadvertent inaccuracies, the internal consistency of its geometry must be assessed before carrying out any geometric analysis. Some simple techniques to analyse the consistency and perspectival accuracy of the geometry of a painting are discussed. Moreover, this work presents new algorithms for generating new views of a painted scene or portions of it, analysing shapes and proportions of objects, filling in occluded areas, performing a complete three-dimensional reconstruction of a painting and a rigorous analysis of possible reconstruction ambiguities. The validity of the techniques described here is demonstrated on a number of historical paintings and frescoes. Whenever possible, the computer-generated results are compared to those obtained by art historians through careful manual analysis. This research represents a further attempt to build a constructive dialogue between two very different disciplines: Computer Science and History of Art. Despite their fundamental differences, science and art can learn and be enriched by each other's procedures.

Keywords: Painting, Geometrical Perspective, Computer Graphics, Single-view Metrology.

Enhancing a Historical Digital Art Collection: Evaluation of Content-Based Image Retrieval on *Collage*

Annette A. Ward, Margaret E. Graham, K. Jonathan Riley and Nic Sheen

Abstract

Searching digital art images is increasingly challenging as collections and numbers of users grow. Text retrieval alone may be inadequate. Content-based Image Retrieval (CBIR) retrieves visually similar matches for a selected painting, sketch, or other image based on colour, texture, and shape. CBIR was added to the Corporation of London Guildhall Library and Art Gallery's 22,000 digital image collection, *Collage*. *Collage* comprises images of London from the fifteenth century to the present day and includes paintings, drawings, prints, sculptures, and other historical items.

Text retrieval of *Collage* images was unaltered. Instead, the optional CBIR search was conducted after an image was selected. Evaluation of CBIR on *Collage* was conducted through an on-line questionnaire. Results from 181 respondents were positive regarding the CBIR addition. Approximately 80 per cent indicated that CBIR searching was interesting and would use it again. Nearly 75 per cent reported that CBIR was a good method of image retrieval. Additional results provided information regarding the usefulness of CBIR, satisfaction with the results, enjoyment of the experience, and demographic characteristics of the respondents. This paper describes the technical application of CBIR to Collage, reports selected results of the eighteen-month user evaluation, and suggests improvements for further application. This research was funded by Resource: The Council for Museums, Archives and Libraries (CMAL/RE/103).

Keywords: CBIR – Content-Based Image Retrieval, Digital Images, Virage® Software.

CHArt – Computers and the History of Art

 Computers and the History of Art looks at the application of digital technology to visual culture, particularly in relation to the study of the history of art, the work of museums and galleries, and of archives and libraries as well as the broader issues of visual media.

CHArt was established in 1985 by art and design historians who were also computer enthusiasts. CHArt's largely university-based membership was soon augmented by members from museums and art galleries, as well as individuals involved in the management of visual and textual archives and libraries relevant to the subject. More recently CHArt has become a forum for the exchange of ideas concerned with all aspects of visual culture. CHArt continues to promote this activity in a number of ways. An annual two-day conference explores topical issues. The group maintains a website, which provides information about activities relevant to its members. Amongst its activities CHArt has run a journal, now replaced by the yearbook, and offers a sponsored prize for students. It publishes Conference Proceedings and an online Newsletter and also hosts an email discussion group. Since 2000 conference proceedings have been available online (exclusive to CHArt Members via the CHArt website). CHArt also sponsors the World Wide Web Virtual Library for History of Art and has initiated a project concerned with documentation of the early digital applications to the history of art.

CHArt's Annual Conference is usually held in the autumn and focuses on current developments in the field. Recent Conferences have included:

1999: Digital Environments: Design, Heritage and Architecture, Glasgow University.
2000: Moving the Image: Visual Culture and the New Millennium. Courtauld Institute of Art, University of London.
2001: Digital Art History. A Subject in Transition. British Academy, London.
2002: Digital Art History? Exploring Practice in a Network Society, British Academy, London.
2003: Convergent Practices: New Approaches to Art and Visual Culture, Birkbeck College, London.
2004: Futures Past: Twenty Years of Arts Computing, Birkbeck College, London.

How to become a member of CHArt

Chart Membership is open to everyone who has an interest in the use of computer and digital technology for the study and preservation of works of art and visual culture. To join, please fill in the online application form on our website: www.chart.ac.uk, and send it to:

CHArt, School of History of Art, Film and Visual Media, Birkbeck College, University of London, 43 Gordon Square, London WC1H 0PD. Tel: +44 (0)20 7631 6181, Fax: +44 (0)20 7631 6107.

Membership Information for 2005

CHArt membership is valid for a calendar year and includes access to online conference proceedings and the CHArt newsletter at www.chart.ac.uk. Individual Membership, which includes a reduced rate for our annual conference, costs £15.00. Student Membership, which includes a reduced student rate for our annual conference is £15.00. Institutional Membership includes a reduced conference rate for up to 3 delegates from your institution, and costs £35.00.

Please visit www.chart.ac.uk for further information.

Guidelines for Submitting Papers for the CHArt Yearbook

1. Texts

Papers should be submitted in hard copy and in electronic PC format, preferably in Word or RTF, and should be of no more than 5000 words. Please submit your paper to yearbook@chart.ac.uk. Please also submit a brief biography of no more than 75 words. Texts are accepted only in English.

2. Conditions

Submission of a paper for publication in the CHArt Yearbook will be taken to imply that it represents original work not previously published, that it is not being considered elsewhere for publication, and that if accepted for publication it will not be published elsewhere in the same form, in any language, without the consent of the editors and publishers. It is a condition of acceptance by the editor of a paper for publication that CHArt acquires automatically the copyright of the text throughout the world. However, the author shall retain a perpetual, non-exclusive licence to publish and distribute the paper under the condition that proper credit is given to the original published article.

3. Permissions

It is the responsibility of the contributor to obtain written permission for quotations where necessary, and for the reprinting of illustrations or tables from material protected by copyright (published or unpublished). No payment can be made for obtaining any copyright required in order to use quotations or illustrations. It is the responsibility of the contributor to obtain written permission for the use of any illustration which remains in copyright. The editor must supply details of any acknowledgement that may need to be placed in captions.

4. Illustrations

All illustrations should be designated as "Fig. 1" etc., and be numbered with consecutive Arabic numerals. Each illustration should have a descriptive caption and should be mentioned in the text. Indication of the approximate position for each illustration in the text should be given.

Illustrations should not normally exceed more than six per article. Please submit illustrations in electronic format, preferably as 300dpi TIFF files.

5. References and notes

References and notes are indicated in the text by consecutive superior Arabic numerals (without parentheses). Please present all references and notes as endnotes in numerical order. In multi-author references, the first six authors' names should be listed in full, then "et al" may be used.

References to books

Author's name and initials (year of publication), [year first published, if different], *full title*, place of publication: publisher, page numbers.

Berners-Lee, T. (1999), Weaving the Web, San Francisco: Harpers, p. 23.

Lasko, P. [1972], *Ars Sacra*, London: Yale (1994).

References to essays/articles in a book

Author's name and initials (year of publication), [year first published, if different], 'title of article', *title of book in full*, editor's name, editor's initials (ed.) or (eds.) if plural, series number (if any), place of publication: publisher, volume, page numbers.

Smith, J. C. (1981), 'The Kings and Queens', *The History Journal*, Smith, P. (ed.), London: Little Brown, pp. 200-28.

References to articles/essays in a journal

Author's name and initials, (year of publication), 'title of article', *name of journal*, volume number: issue number, page numbers.

Jones, T. A. (1990), 'The British Coin', *British History*, 19:1, pp. 98-121.

References to essays/articles in conference proceedings

Author's name and initials, (year of publication), 'title of essay' *title of proceedings*, venue and date of conference, place of publication.

Grindley, N. (1999), 'The Courtauld Gallery CD Project', *Computing and Visual*

Culture. Proceedings of the Fourteenth Annual CHArt Conference, Victoria and Albert Museum, 24-25 September 1998, London.

Authors must check that reference details are correct and complete; otherwise the references cannot be used. As a final check, please make sure that the references accord with the citings in the text.

References to online publications

References to online publications should include the URL and the date last accessed.

How Does My Home Work?

Heating

Chris Oxlade

www.raintreepublishers.co.uk
Visit our website to find out more information about Raintree books.

To order:
☎ Phone 0845 6044371
🖨 Fax +44 (0) 1865 312263
✉ Email myorders@raintreepublishers.co.uk

Customers from outside the UK please telephone +44 1865 312262

Raintree is an imprint of Capstone Global Library Limited, a company incorporated in England and Wales having its registered office at 7 Pilgrim Street, London, EC4V 6LB – Registered company number: 6695582

Text © Capstone Global Library Limited 2013
First published in hardback in 2013
The moral rights of the proprietor have been asserted.

Edited by Daniel Nunn, Rebecca Rissman, and Catherine Veitch
Designed by Joanna Hinton-Malivoire
Picture research by Elizabeth Alexander
Production by Alison Parsons
Originated by Capstone Global Library Ltd
Printed and bound in China by Leo Paper Products

ISBN 978 1 406 23766 5
16 15 14 13 12
10 9 8 7 6 5 4 3 2 1

British Library Cataloguing in Publication Data
Oxlade, Chris.
Heating. – (How does my home work?)
697-dc22
A full catalogue record for this book is available from the British Library.

Acknowledgements
We would like to thank the following for permission to reproduce photographs: Alamy pp. 6 (© Oleksiy Maksymenko), 9 (© Gareth Byrne), 13 (© Jon Parker Lee), 17 (© Ted Foxx), 20 (© Angela Hampton Picture Library), 21 (© PhotoAlto), glossary photo: boiler (© Gareth Byrne); Science Photo Library p. 10 (Edward Kinsman); Shutterstock p. 4 (© StockLite), 5 (© Kuznetsov Dmitriy), 7 (© Ant Clausen), 8 (© David Hughes), 11 (© vadim kozlovsky), 12 (© glennebo), 14 (© Leo Francini), 15 (© Ian Bracegirdle), 16 (© Calek), 18 (© Georgios Alexandris), 19 (© THP | Tim Hester Photography), 23 (© THP / Tim Hester Photography, © Ant Clausen, © glennebo, © Georgios Alexandris, © David Hughes, © Calek).

Cover photograph of a fireplace reproduced with permission of Shutterstock (© Jitloac). Background photograph of blue flames of a gas burner inside a boiler reproduced with permission of Shutterstock (© Dmitry Naumov).

Back cover photographs of (left) a gas fire reproduced with permission of Shutterstock (© Ant Clausen), and (right) insulation reproduced with permission of Shutterstock (© glennebo).

Every effort has been made to contact copyright holders of material reproduced in this book. Any omissions will be rectified in subsequent printings if notice is given to the publisher.

We would like to thank Terence Alexander for his invaluable help in the preparation of this book.

Disclaimer
All the Internet addresses (URLs) given in this book were valid at the time of going to press. However, due to the dynamic nature of the Internet, some addresses may have changed, or sites may have changed or ceased to exist since publication. While the author and Publishers regret any inconvenience this may cause readers, no responsibility for any such changes can be accepted by either the author or the Publishers.

Contents

Some words are shown in bold, **like this**. You can find them in the glossary on page 23.

What is heating?

fire

Heating is how we keep our homes warm when the weather is cold.

We heat our homes with heaters, **radiators**, and fires.

We also use heating to heat up water.

We use the hot water for washing, baths, showers, and cleaning our homes.

How do heaters work?

Some heaters work using electricity.

The electricity makes the heater hot. This makes the air around the heater warm.

gas fire

Some heaters work using **fuels** such as gas, oil, coal, or wood.

The burning fuel heats the air in your home.

How do radiators work?

radiator

Do not touch a hot radiator.

Some homes have heaters called **radiators** that make them warm.

Radiators are hot because they are full of hot water.

boiler

A **boiler** burns **fuel** such as gas to heat the water.

A pump pushes the hot water through pipes to the radiators.

Will my home stay warm?

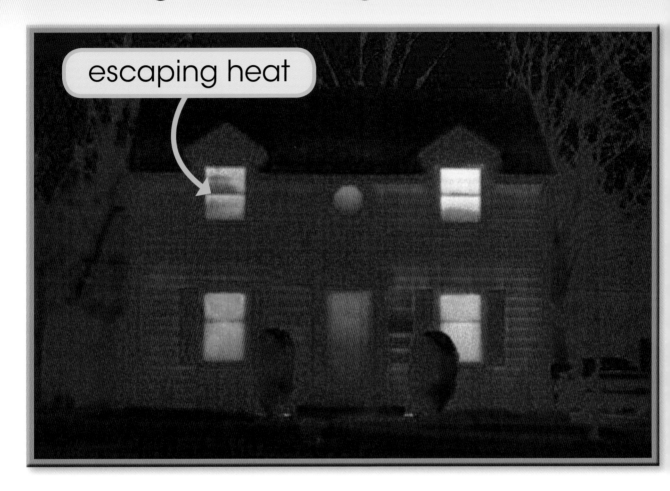

When it is cold outdoors, heat from inside a home leaks away.

In this picture, the bright colours show where most of the heat is escaping.

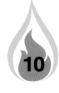

Heat escapes quickly through open windows and doors.

We have to use more **fuel** or electricity to replace the heat that is wasted.

Can we stop heat from escaping?

insulation

We stop heat escaping from homes with material called **insulation**.

Most homes have insulation in the roof and in the walls.

double glazing

These windows have two sheets of glass in them called double glazing.

Double glazing helps to stop heat from escaping through the windows.

Where do fuels and electricity come from?

oil rig

Oil, gas, and coal are found deep under the ground.

This oil rig is getting oil from under the seabed.

Electricity is made at electricity power stations.

This power station burns coal to make electricity.

How do we stop homes from getting too hot?

thermostat

We use a control called a **thermostat** to say how warm we want a room to be.

The thermostat turns the heater off when the room is warm enough.

16

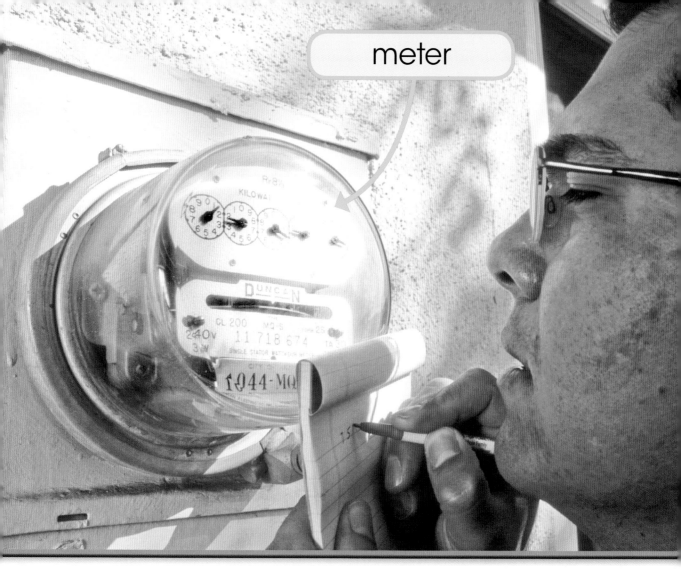

meter

Your home has an electricity meter that measures how much electricity you use.

If you turn down your thermostat a bit, you can save electricity.

Is heating homes bad for our planet?

pollution

Burning **fuels** for heating or to make electricity makes **pollution** in the air.

Pollution is bad for our planet.

Scientists believe that burning fuels is also causing **climate change**.

Some countries may have more storms or droughts because of climate change.

How can we save heat?

Turn down heating to use less **fuel** and electricity.

That will save your family money, and it helps the planet, too.

You can wear extra clothes indoors instead of turning up the heat.

Also, keep doors and windows shut in the cold weather to keep in the heat.

Saving heat diary

What things can you and your family do to save heat in your home?

Copy the list below. When you do one of the things on the list, put a tick next to it.

Things to do to save heat

- Turn down the **thermostats** on your heaters.
- Keep doors and windows closed when it is cold outside.
- Wear extra clothes instead of turning up heaters.
- Check that your home has **insulation**.
- Do not leave hot water taps running.
- Take a shorter shower.

Glossary

 boiler machine that burns fuel to heat water

 climate change when there is a change to normal weather conditions

 fuel material such as coal, oil, or gas that burns to give heat, light, or power

 insulation material that stops heat escaping through the walls and roof of a home

 pollution harmful things in the air, water, or soil. It is caused by humans.

 radiator heater that is full of hot water. Some heaters are filled with hot oil instead.

 thermostat control that turns radiators or heaters on or off, depending on how hot or cold it is

Find out more

Books

Energy (Reduce, Reuse, Recycle series), Alexandra Fix (Heinemann Library, 2008)

Global Warming (Protect our Planet series), Angela Royston (Raintree, 2008)

Websites

www.childrensuniversity.manchester.ac.uk/ interactives/science/energy/renewable.asp
Do an activity about renewable sources of energy, on this website from the University of Manchester.

www.sciencemuseum.org.uk/on-line/energy/site/ EIZGame4.asp
Play a game about renewable sources of energy, on this website from the London Science Museum.

Index